The Innocent Artists

Student Art
from Papua New Guinea

The Innocent Artists

Student Art
from Papua New Guinea

Catherine Baker

Blandford Press
Poole Dorset

First published in the UK 1980
by Blandford Press Ltd.,
Link House, West Street,
Poole, Dorset, BH15 1LL

British Library Cataloguing in Publication Data

Baker, Catherine
 The innocent artists.
 1. Children's art – Papua New Guinea – Kerowagi
 2. Art, Chimbu (New Guinea people)
 3. Art, Primitive – Papua New Guinea – Kerowagi
 4. Kerowagi High School
 301.5'6 N352

ISBN 0 7137 1000 4

Typeset in Monophoto 12/14pt Garamond
and printed in Great Britain by
BAS Printers Limited, Over Wallop, Hampshire

Contents

Foreword

Those who are fortunate enough to be able to buy, or borrow, this book are in for a surprise. But if they are like me it will be a surprise tempered by an initial incredulity. 'Did young people *really* produce such work?!' The answer, of course, is an emphatic 'Yes, they did, and continue to do so.' Why did I, and I suspect others will react similarly, react in this way? The brief answer is that it was a reflex, conditioned by a lifetime spent in education (i.e. western-type schooling) and the consequential expectations I have of children's art. No matter that my experience has taken place in many diverse cultures and parts of the world; it has all been connected with schools and schooling, and the art I have seen is produced as part of the 'schooling process', or at least conditioned by it. Among young children, art is characterized by originality, spontaneity, and the liberal use of colour, untrammelled by considerations of perspective and composition. Even so, the use of conventions copied from older children or adults (teachers?) soon appears and the originality begins to suffer. By the time adolescence is reached, spontaneity has been crushed and the work is stiff and formal in an attempt to achieve the accepted norms set by adult society; that is, all except the lucky few who are encouraged and guided by gifted teachers.

How does one preserve the spontaneity and originality of early childhood and at the same time, teach the essential skills of painting, drawing, pottery and so on? Is it even possible to achieve this? The comparison between art and other forms of expression is obvious. Take, for example, the richness of oral expression by young children and the stilted writing of adolescents and most adults, produced at a cost of much pain and effort! — and in the case of art, relying heavily on conventional forms. Here, again, the process of teaching and learning the essential skills of written communication has driven out spontaneity and originality. Must innocence always be sacrificed on the altar of technique?

Catherine Baker's 'innocent artists' are a wonderful example of the richness which results from the marriage of innocence *and* technique. But the

question still remains. How did they acquire their marvellous skill in draughtsmanship? Perhaps because manual dexterity is an essential part of their daily life? Whatever the reason, I am delighted that Catherine has succeeded in bringing to the attention of what will be, I am sure, a wide readership, the skill and imagination of the young artists from the Chimbu Province of Papua New Guinea.

John Callander,
Chief Education Officer,
Commonwealth Institute.

Introduction

Most of the text of this book is a personal account of my experience as a teacher of expressive arts in the newly independent country of Papua New Guinea. Whether it will add to the reader's appreciation of the remarkable drawings which form the main part of the book I do not know. I hope so. It is offered in good faith. In my opinion the drawings speak for themselves as highly imaginative and finely executed works of art. Numerous people have shown enthusiasm for the work knowing virtually nothing about the background of the young people responsible for them. Perhaps this is as it should be. Perhaps art, as a manifestation of the spirit, should have an elemental rather than a cultural appeal. But we westerners like our facts and figures, turning the whole of creation into a series of dubious sciences.

The young students of Kerowagi High School certainly didn't give me many facts and figures to go by. I taught them virtually nothing, and as my amazement at their work grew, I heaped upon them all the questions that I have since heard so often from others—Where do the ideas come from? Is this kind of work traditional? What are the influences involved here? Their replies echoed a statement made by the successful Papua New Guinean artist, Akis—'I just let my hand go and my hand made the drawing'.

They were very nonchalant about their work, reluctant to talk about it or even to look at it when finished. They were almost all highlanders, in the twelve to sixteen-year-old age group, with little experience outside Chimbu Province. The highlands, in the heart of Papua New Guinea, were originally thought to be uninhabited, and the fact that white men didn't actually get to Chimbu until 1933 is sufficient testimony to its isolation. Children barely a generation removed from the Stone Age could hardly be expected to analyse their art in terms that would satisfy us.

The influences upon them were no doubt numerous, but perhaps none so great as what seems to have been Chimbu's *lack* of tradition in visual aesthetics. I suppose in saying that I am likely to invite the criticism of all those fans of the great Chimbu extravaganza—body decoration. It goes for most of

[1]

the people of Papua New Guinea that nobody knows how to dress up quite like them, but the highlanders really excel. All manner of things, from birds of paradise plumage to (latterly) coke bottle tops, are used to striking effect. Face painting, too, is a vital element, often for a cult rather than a decorative purpose. Yes, aesthetic prowess in body decoration is undeniable. But in terms of pottery, carving and painting Chimbu and the highlands in general is unrenowned.

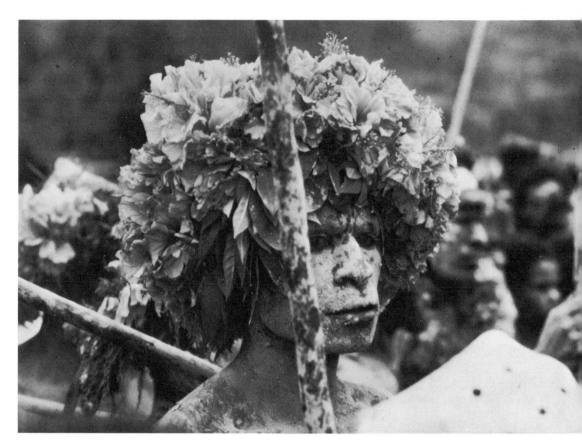

Chimbu warrior celebrates the establishment of the Chimbu Provincial Government, 1977. He wears pink hibiscus in his hair.

In the lowlands and among the coastal people the story is different. There, a very strong artistic tradition, as a shorthand for clan culture rather than 'art' as we term it, has long been in existence. In their book, *Arts of the South Seas*, published in 1946, Ralph Linton and Paul Wingert made the following comparison: '[The highlanders] live in the high central mountains of the island and have little contact with [outsiders]. Only a small number of types of objects, such as stone axes, slate knives, net bags, bows and arrows, are made by the known Negrito tribes. Many of these implements are well-executed but have little distinction of shape or decoration.

[2]

'The well-developed styles that have made New Guinea an important centre of Oceanic art come from the eastern and northern regions . . . and from the western part of the island. . . . The art of the Sepik River region has more variety and is richer than that of any other section of Oceania.'

Today, and from the international point of view, art from the Sepik Province is almost all that is known of Papua New Guinean art. Almost every tourist and expatriate worker makes a point of leaving the country with at least

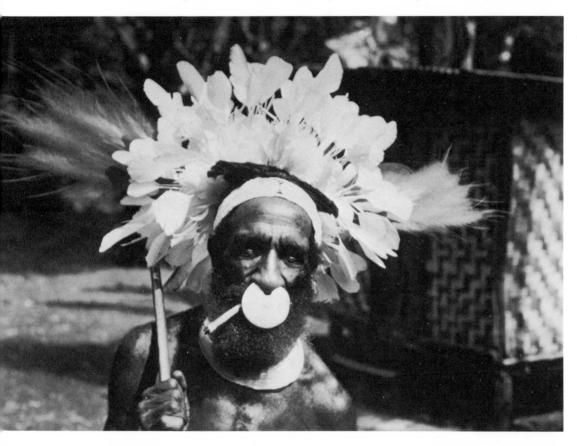

Chimbu warrior at a 'sing sing' near Kerowagi.

one Sepik artefact among his baggage. The lowlands peoples' traditional skills in pottery and carving and the painting of artefacts and houses are truly striking. They are also stultified. Intimately linked with the values of traditional society, their vitality has floundered in the face of introduced political and economic systems and new religious beliefs. When their art re-vitalises, as I believe it will, perhaps it will be along highly original and individualistic lines. For the moment, however, where coastal art survives, it is in reproducing pieces that are sought after by tourists and for export to the artefact shops of the world.

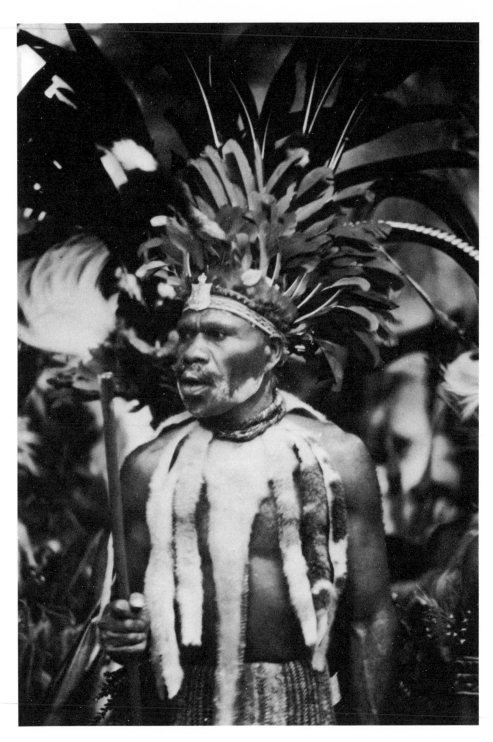

Chimbu warrior during a 'sing sing' at Kerowagi.

Somewhere therein lies a tale. Akis, the semi-literate highlander who made his way to Port Moresby, the capital, the man who just let his hand go and made the drawing, has found great success as an artist. Prints of his paintings and drawings are found in many of the expatriate (mainly European) homes in Papua New Guinea. His work, however, like that of the coastal artists, appears to be bogged down in its own success. It is repetitive rather than exploratory. It is no longer a free and vital expression of the spirit

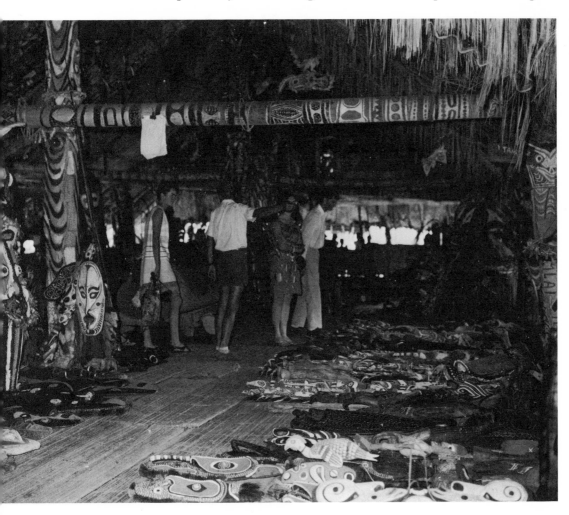

Tourists looking at artefacts in the Haus Tamboram at Angoram in the Sepik district.

of Akis, but rather what the Europeans are likely to buy. The same seems to apply to the work of Kauage and that of Barnabas India, two other prominent Papua New Guinean artists. Is this a criticism? Perhaps. If it is, and if Akis, Kauage and India ever find out, then I hope they will forgive me. I know they have to eat, and, after all, they didn't invent the economic social

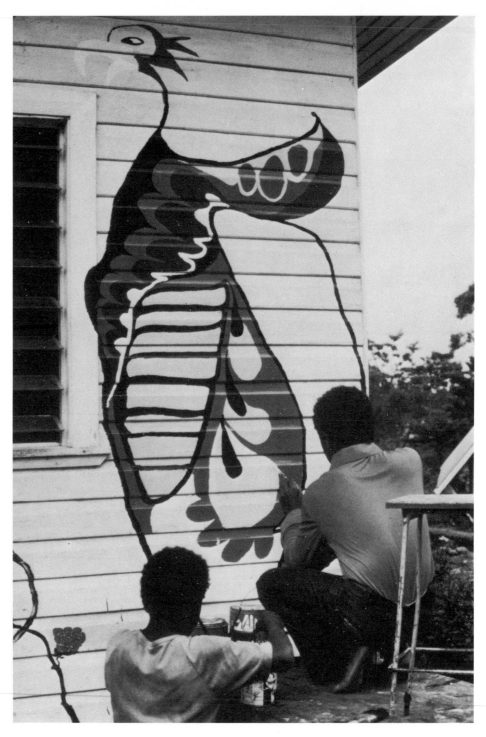

Two Grade 8 (Form 2) students decorating one of the art classrooms.

theory. For that we can blame the English, and for that, to quote Thomas Mann, 'the genius of humanity can never forgive them'.

I believe that the 'genius of humanity' was at work among the Kerowagi students during their art classes. Their work was full of invention, surprise, and bizarre association of imagery. In spite of some peoples' insistence that they must have been strongly influenced by their own culture, I find little evidence to support this. In view of the lack of a strong artistic tradition in Chimbu, there was little to inherit from previous generations, and in view of the extremely rapid westernisation of their society, they find themselves in a cultural limbo where they are free to display far greater imaginative and visionary powers than do artists whose cultural conditioning is inescapable.

There are few cultural ties to bind; therefore their imagination is boundless. They do not draw to serve the clan, or for money, nor does their work seek to influence. This freedom enables them to draw upon numerous sources for their inspiration. Now they are exposed to their own country's coastal art, to western art, to comic books, to movies, to books about Africa, books about American Indians and the USSR. All this, together with their feelings for the parallel world of the spirits, has resulted in an extraordinary capacity to invent.

Look at the detail—and the humour—in so much of the work. It is a wonderful form of doodling. This was how they drew, with ease, no planning ahead, but just letting their hands go. To me, here was some of that genius Thomas Mann meant, that vital creative energy which is at the source of the only things that really matter—true art and true religion. And in the face of my enthusiasm my Chimbu students probably thought I was crazy.

[1]

A Stone Age Survival

Talk of Papua New Guinea often brings the response 'Oh, yes, in Africa' from informed people, and, 'Oh, yes, in South America' from the less fortunate. In fact, what is listed as the world's second largest island (Greenland being the first) is just north of Australia extending almost to the equator. For the most part it is a moist green land teeming with a flora and fauna all its own. It was 500 miles (800 km) to the west of the island that Alfred Russel Wallace, the evolutionist who coincided with Darwin, marked for science the meeting place of the animals and plants from Asia in the north west and those from Australia in the south. In New Guinea the meeting took place amid a setting of tropical rain forests, cloudy mountains, dry savannahs, coastal swamps and giant rushing rivers, and animals and plants followed their own unique evolutionary paths. It is the land of the birds of paradise, the tree kangaroo, and of more than three thousand different species of orchid. It is a land of amazing variety in visual stimulation.

For centuries New Guinea lay outside what we call history, visited occasionally by slave ships from the Celebes or by adventurers from Spain and Portugal who brought home tales of primitive and fearsome headhunters. The indigenous people of the island are Melanesians, very different in appearance from their neighbours in South East Asia and Polynesia. Generally speaking they are darker in skin colour and have crinkly hair, although a very wide variety of physical types is found throughout New Guinea. Moreover, the bewildering diversity of peoples doesn't end with physical characteristics. They are also split by more than seven hundred distinct languages, a fact which turned the missionaries' task into a linguistic nightmare. Today, the English language, together with Melanesian Pidgin which has become the lingua franca of the country, aids the concept of nationhood.

The origins of the people are still unknown. It is thought that there were several waves of migration into the country, perhaps some from Asia. It is

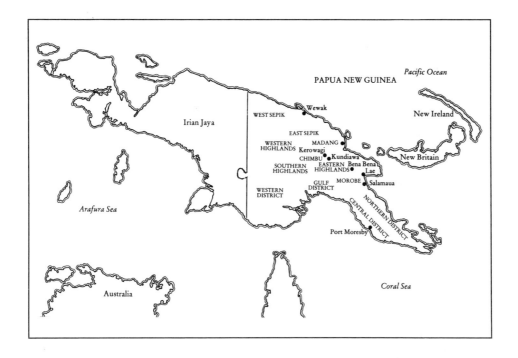

also thought that the present day highlanders are descendants of the original immigrants, the lowlands having been peopled at a later date. But this is all speculation. The archaeologists have not been especially active in Papua New Guinea and the ancient stories of the island, unwritten, are receding into the mists of an earlier civilisation.

Until colonisation began in the 1880s, New Guinea had its share of Dutch, German, French, British and Asian traders. They touched the shores, never venturing far inland. The mountains, meanwhile, protected the highlands people from all but the occasional batch of beads, mirrors, or sweet potatoes that managed to filter through. Happily for the people of New Guinea, colonialism was winding down by this time and so, unlike the Australian Aborigines and the Indians of America, they were spared the worst of its excesses. Holland claimed the western half of the island, which today is known as Irian Jaya and is, albeit unwittingly, a part of Indonesia. The remaining 183,540 square miles (approx. 475,000 sq. km), the eastern half of the island, was divided between the British and the Germans. In 1901 British New Guinea, to the south, was transferred to the new Commonwealth of Australia. It was re-named Papua. During World War I Australia occupied German New Guinea, called it just plain New Guinea,

and retained it after the war under a mandate from the League of Nations. Since then, the Australians have been the main agents of cultural change in the country.

In both Papua and New Guinea exploration proceeded slowly. It was not until the early 1930s that the vast populations of the highlands were found nestling among the mountains. Of the first white men into the new areas, some were government officials, some were seeking gold. Although some

Typical Chimbu scenery; on the left is the road to Gembogl District in Northern Chimbu, where many of the students came from. A friend on a motor bike is just disappearing around the corner.

objects of western manufacture had previously reached the highlanders through trade with their neighbours, there was no direct contact with outsiders until 1931, during the exploration of the Eastern Highlands by Michael Leahy, a prospector. A further expedition was organised two years later to penetrate the unknown regions further to the west—now known as Chimbu Province and the Wahgi Valley.

Of his first flight over the region on 8 March 1933, Michael Leahy says: '[We] laid to rest for all time the theory that the centre of New Guinea is a mass of uninhabitable mountains. What we saw was a great, flat valley, possibly

twenty miles wide and no telling how many long, between two high mountain ranges, with a very crooked river meandering through it. Below us were evidence of a fertile soil and a teeming population—a continuous patchwork of gardens, laid off in neat squares like checkerboards, with oblong grass houses, in groups of four or five, dotted thickly over the landscape. . . . When consideration of our gasoline supply forced us to turn back, the western limits of the valley were still lost in the haze of the distance.

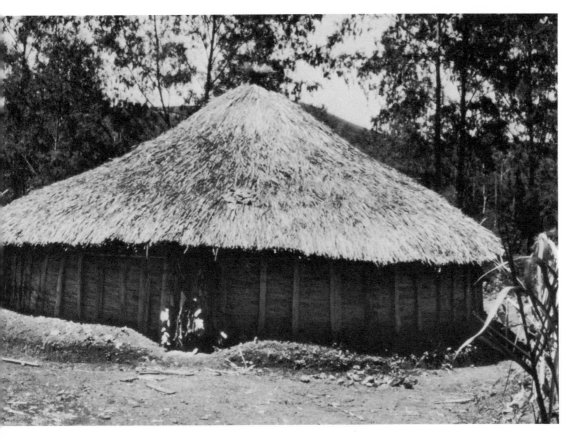

Typical Highlands village house.

'The results of that flight made front-page news all over the world, and hastened preparations for an overland expedition.'

Thus Michael Leahy and Jim Taylor, who was Assistant District Commissioner at Salamaua in Morobe Province, set out from Bena Bena with the rest of their party on 28 March to establish contact with people who had never before seen white men. While the expedition met with some threats of violence and some theft, the initial reaction from the people in the Chimbu Valley was generally speaking one of curiosity or superstitious awe.

The Chimbu people had no large villages or settlements. Their checkered

[11]

gardens, tended by the women, sported individual farm houses, built by men of fantastic appearance. The people among whom the expedition passed as it crossed the Kerowagi River and continued into the middle Wahgi Valley had dried snakes and possum tails looped through their ear lobes, and wore brilliantly coloured bird wings and the spiked bodies of whole lorikeets in their hair. Long shimmering plumes extended from noses and sprouted from heads—and this was just an ordinary day. On special occasions the offices of

Typical Chimbu settlement.

the orange-red Raggiana Bird of Paradise and the gleaming turquoise Superb Bird of Paradise would be called upon, to stunning effect. Further up the Wahgi Valley the appearance of the natives was colourful, but not quite so extravagant.

No matter how remarkable the people of Chimbu seemed to Leahy and Taylor, their feelings of surprise and wonder must have paled in comparison with those of the natives themselves. 'At first', wrote Taylor, 'we were people come back from Paradise looking for our homes'. But after the wonder had worn thin further contacts were sometimes hazardous—'Later

we were regarded as rejects from Paradise.' To a people who had never looked beyond the nearest line of mountain ridges, strangers were traditionally regarded with fear and suspicion. With these new strangers such feelings were mixed with an overwhelming desire for their goods, their 'cargo', as all material effects are locally called. Attacks were made, and twice on the return journey Taylor had to shoot to kill. Swift punishments had their effect, though it was also due to the gentle influence of the missionaries

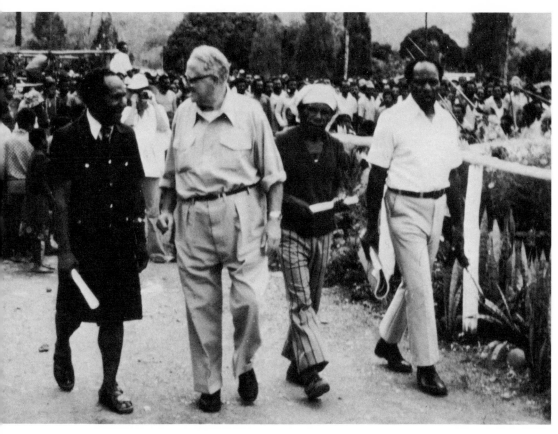

Mr Jim Taylor (second from left), who still lives in Papua New Guinea, with various Chimbu officials at a function celebrating the establishment of the Chimbu Provincial Government, 1977.

that Australian administration of the highlands was finally instituted without any major upheavals.

[2]

The Excitement of Change

In Papua New Guinea the archaeological record is extremely limited, though it has been estimated that the earliest people in the highlands, about 10,000 years ago, were hunters and gatherers using a variety of bone and flaked tools. Gardening is believed to have begun about 5,000 years ago, and pigs were introduced from the lowlands. Cultivated taro was most likely the mainstay of the diet. Forests were cleared and soil prepared with ground stone axes. The highlands soil is rich and the rainfall abundant; agricultural adaption probably stimulated population increase and land shortage. Today Chimbu is the most densely populated province in the country (approximately 200,000 people), and the lower mountain slopes a patchwork of gardens at crazy angles. I once heard that in some gardens people would tie themselves to the nearest tree to prevent themselves falling off while cultivating!

Land shortage was one of the reasons for the fighting, the population movements and migrations which seem to have been the order of the day in the highlands. Groups in competition for resources increased in scale and development. The main weapons used were bows and arrows, spears and axes. Fearing retaliation and sorcery, people driven from their territory preferred to avoid re-settling too close to others.

Paula Brown, an anthropologist with a long history of Chimbu-watching, says in her book *The Chimbu* that no centralised political control appears to have developed and no great wealth accumulated: 'There were always big and small tribes, big men and transactional activities at all levels. Chimbu has had many centuries of land shortage, fights and expansion, migration and resettlement.

'There was no surplus or accumulation of wealth or use of economic advantage to change the political or economic system. There were always big men, competitions, rivalry, but no permanent advantages . . .'

The pre-colonial Chimbu world was ever-changing and unpredictable. Perhaps this goes some way to explaining the relative speed with which they

[14]

This type of cultivated garden (the angle must be about 70°) is not an unusual sight in populous, mountainous Chimbu. The crops would probably be sweet potato, taro, spinach.

have accepted the new order. Nowadays the factors governing the land, life, and economic relations in Chimbu have been greatly tempered by the introduction of cash crops, particularly coffee. A co-operative such as Chimbu Coffee would not have had much chance of success in the old days. Chimbu was a competitive society, but it was competitive along highly individualistic lines.

In their art, too, the tendency was to emphasise the prestige of the man

Young Chimbu daughter of local 'big man'. Her enormous head-dress of bird of paradise plumes displays her father's wealth.

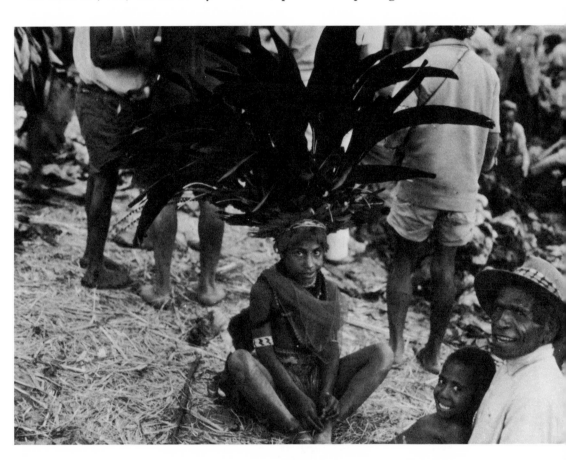

rather than the social group. It was largely confined to self-adornment. Headdresses were skilfully and painstakingly put together to display wealth, and painting was restricted to bodies. Carving was virtually unknown and pottery a late introduction from the lowlands, where art was much more an expression of the social group. Artistic expression in the lowlands reinforced the values of society, a kind of symbolism which was best seen in their great ceremonial houses. Built with bush timber and held together with split-cane lashings, the *haus tambaran* are huge but refined structures, making finely

[16]

decorated settings for ceremonies and houses for sacred objects. The ceremonial house expressed the solidarity of the group and its prestige.

Here the difference in social values between highlands and lowlands is quite marked. In his book, *Papua/New Guinea*, Peter Hastings says: 'These differences . . . may be relevant to the general enthusiasm and skill that the highlanders have shown in exploiting the opportunities offered by the arrival of the European economic order and cash crops. Many highlanders have shown remarkable entrepreneurial skills with no previous experience in handling cash, while in contrast many lowland cultures have been the despair of development economists for decades.'

What seems to be almost an irreverence for the past among the Chimbus has intrigued quite a number of people. Talk of the speedy acceptance of the white man's ways has raised more than one liberal eyebrow back in Britain—it is almost as though the victims of colonialism ought not to be allowed to behave in such a way. And yet the scholarly sources and the day-to-day observers agree; the Chimbu peoples' reactions to the Australians' arrival and administration was on the whole a positive one.

The newly arrived masters found it difficult to discover any traditional standards or values. Many traditional ornaments used for body-decoration were cast aside in favour of tin can tops, rags, beads, anything of the white man's cargo that they were given or managed to acquire in some other way. Sunglasses were especially popular. As far as the Chimbus were concerned, it was obvious that the white strangers were far better off than they. The whites didn't work, they didn't clear land or plant it, and yet they had an enormous amount of cargo that either came from the sky or was carried in by other natives. And the cargo was worth having—warm blankets and clothes (it can get cool in the highlands), shoes, steel tools, sweet food. Here was the source of the initial attraction.

Further attractions were to follow. Bill Standish, scholar, liberal, and Chimbu-watcher of many years standing, writing in the October 1973 issue of *New Guinea* said: 'The coming of the white man was in general welcomed. No longer was there need for unceasing vigilance as the threats of war and uncontrolled payback receded. Larger internal or external conflicts could be taken to the *kiap* [captain], a neutral arbiter. People moved down from the hills into valleys which were previously disputed territory and used mainly as fighting grounds. No man's land became food and coffee gardens, and members of groups previously mortal enemies now rubbed shoulders daily as they moved along roads they had been persuaded to build. Government and mission stations were also built on battlegrounds, which are still used in sublimated warfare such as the socially acceptable outlet for aggression known as football.'

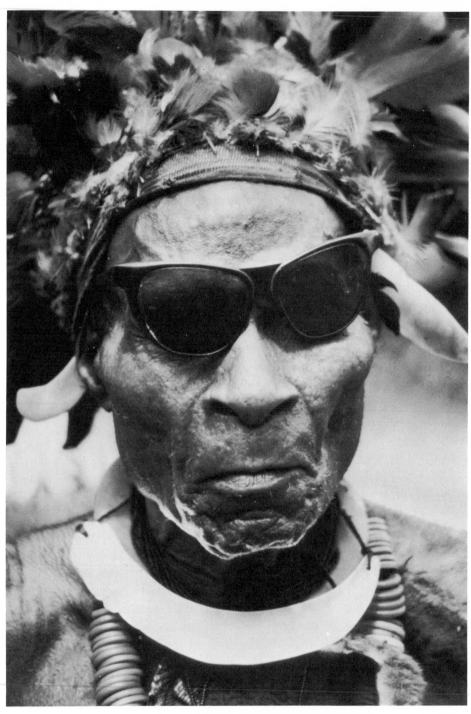

This was one of our neighbours, who one day tried to sell us a tree kangaroo, and who always wore 'national dress' with the sunglasses.

The new mission stations were packed to capacity. Generally speaking the missionaries were gentle and patient teachers who did not make too many demands of their Stone Age converts. Father Schaefer, a Catholic missionary quoted in Colin Simpson's *Plumes and Arrows*, said after 20 years in Chimbu: 'I never expected to make [so] much progress. . . . I'm sure it's because we worked as anthropologists first, and then as Catholic missionaries. The study of the people's customs led us to the conclusion that these were not a sinful people; rather they were ethically and morally indifferent. It was not necessary that they abandon a great many customs – only those that are sinful, such as polygamy and divorce.'

The Chimbu desire for variety and entertainment was carried into the mission stations and was certainly partially satisfied by the ritual, the pageant and the doings of fellow-worshippers. Discussion of Christian philosophy was minimal, however, and evidence of true spiritual awakening scant. My church-going students at Kerowagi certainly didn't appear to me to be very devout Christians, but that observation of church-goers I would not confine to Chimbu alone. I tend to agree with Bernard Shaw's remark that the only thing wrong with Christianity is that nobody's ever tried it.

Whatever the reasons for the popularity of the new missions, Christian teaching did not conflict seriously with any cosmological beliefs the Chimbus might have had. They seem to have lacked any systematic beliefs, and no stories have been heard of describing a fixed order of nature. Paula Brown heard many stories during her long contact with Chimbu, but most were concerned with how certain day to day practices originated and revolved much around gardening, pigs, cooking, and various human characteristics. My own experience was similar. I read and heard numerous clan legends, of which the following tale of an ardent lover, quoted in *Time Belong Tumbuna*, is a fairly typical example:

Long ago there lived a young man called Deboninigins who owned a magic dog. He had plenty of pigs and his own garden, but no wife.

One day as he was returning from hunting, he saw a group of young girls washing in the river. One of the girls was very beautiful. The man told his dog, Opöi, that he wished he could have the woman for his wife. It was against tribal custom to approach a strange woman from another clan. So Opöi ran off alone and Deboninigins returned home.

While the beautiful girl, Ambamboib, and her friends were bathing, Opöi stole her *bilum* bag and her *pulpul* [skirt] from the river bank and ran away into the bush. The girls called after him and chased him. They asked him if he was a real dog or a man. Finally, all the girls had given up the chase and Ambamboib was alone in the bush in the gathering darkness. She called again to Opöi that she

would follow him if he would return her *bilum* and *pulpul*. Opöi appeared with them and the girl followed him back to his master's house. When Deboninigins saw what Opöi had brought for him he was very happy.

The two slept in Deboninigin's house and the next day they travelled to Ambamboib's village with a pig for feasting. In the girl's village all were mourning as they thought she was dead. When the parents saw the young couple, they were not angry. The pig was killed and cooked, grease was smeared on everyone and a great feast was held to celebrate the marriage.

Because of Opöi's clever trick, from that day on, men can meet women of different clans. This is arranged by holding *Ampkanana*, where all the single girls come and 'turn their heads' and sing with the men who may eventually marry them.

Many of these stories I found quite charming, others quite violent, and still others quite risqué. None were cosmic in scope. This intrigued me in view of the little I do know about the Australian Aborigines, with whom New Guineans are sometimes (misguidedly) compared. Throughout Australia the central theme of Aboriginal legends and art lies in the sacred religious beliefs of the people. The link between themselves and the eternal spiritual powers that form the mainspring of their life is a day to day reality. A deeply religious people, the Aborigines suffered great emotional and spiritual loss in reaction to colonial change.

But the Chimbus do not regard the past as something to be revered. One doesn't find many of them sitting around and talking about the good old days. They seem to concentrate on the present, rarely thinking of the past or planning for the future. The only constant they recognise is change—and that in itself is perhaps some testimony to their past.

[3]

Willy-nilly into the Twentieth Century

In its task of establishing communications and a peaceful order throughout the highlands, the Australian administration was by and large successful, though clan fighting, which has increased since independence in 1975, is again causing some concern. Communication by road is adequate, and the main artery, the highlands highway, running from Lae to Mendi, is in the process of being paved. Airstrips have been built in some very unlikely places, and radio and newspapers have found their way to Chimbu. Public motor transport for those who require it is available in the form of PMVs—public motor vehicles. PMV fares are quite high in comparison with those of, say, Asia. But there is coffee in Chimbu, and therefore there is money.

The end of the coffee season is synonymous with a giant spending spree, and the local trade stores, carrying anything from Chinese thermos flasks to Tiptree Tawny Orange Marmalade, are alive with the sounds of getting and spending. There aren't many local millionaires in Chimbu, but nobody is starving.

The new order has brought with it some concept of Papua New Guinea—'our nation'—particularly among the young educated people. To the young businessmen and politicians eager to promote Chimbu interests at a national level, the capital, Port Moresby, is just a short flight away.

But it is with the small farmer that the soul of Chimbu still lies. His gardens provide subsistence for himself and his family, and the bit of coffee he manages to produce brings him some extra cash for cargo. As far as he is concerned, Port Moresby may as well be in Australia, as many Chimbus originally believed it to be. Local concerns are all that order his world, and if, unlike when he was a child, he is now wearing T-shirts and eating tinned fish, he doesn't give much thought to the broader implications of this. He is the father of the students at Kerowagi High School, looking forward to a comfortable old age with all his children in good jobs. Unlike his student children, he does not lead a split life. The impact of change has not hit him

quite so dramatically. Village life goes on. Its tasks are allotted much as they always were. He clears the land for the gardens, he digs the ditches and builds the fences to keep the pigs on their best behaviour. With other men from his clan, he cuts the framework timber for his houses, puts up the stakes and makes the grass matting for the walls, and poles and thatch for the roof. His wife might live in a separate house, and he builds this too. The men's house, larger and central to the life and co-operation of the men, is built by a group

A street in Kundiawa town.

usually on a hilltop. A house lasts about four years.

The women usually help with house building by cutting the grass for thatching and bringing it to the men. For the main part, however, their daily tasks revolve around planting and tending the gardens, caring for the children and cooking. Chimbu women are sturdily built and extremely hard-working. They seem to do most of the fetching and carrying that needs to be done around the village and it's not unusual to see even the oldest women, now frail with age, bent double under huge bags of vegetables, going about their business with a smile and a greeting. They are not highly regarded by

[22]

their men, these Chimbu women. Traditionally there has been mistrust between the sexes and a separateness that carried on even into marriage, though this seems to be declining. Still, arguments between men and women are frequent, loud, abusive, and quite quickly forgotten. Many were the times I heard the term *rubbish meri!* (rubbish woman) hurled at girl students by boy students, but the girls were quite vociferous in their responses, and arguments rarely lasted long.

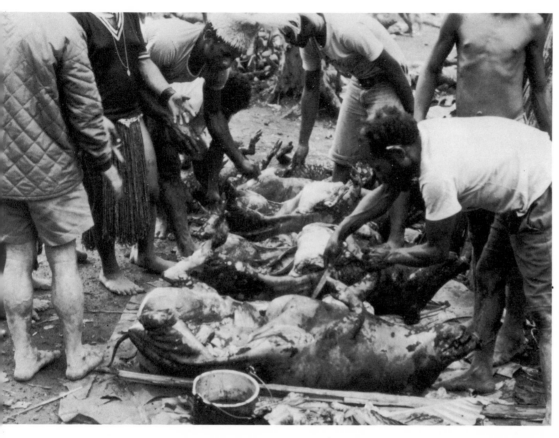

Pig kill at Pari village near Kundiawa.

Traditionally, young men would have little to do with girls until after initiation. The boys to be initiated would fall into a wide age-range, since the great pig-killing ceremonies that were held after initiation took place only every seven to ten years. There were no mystical controls on the pig ceremony. Paula Brown tells us that the main aim was group welfare and fertility. The pigs were cooked at ceremonial grounds to please the ancestors. The pig ceremonies continue today, although their social significance is becoming hazier as more and more young men leave home for school. Many of the older boys at Kerowagi High School had not been initiated—and did not

[23]

particularly like to talk about the fact. Had they been leading normal village lives they would have been living and working with their fathers, learning hunting and farming skills from them, and preparing for marriage. After the bride-price had been agreed and the marriage conducted they would become full householders and gardeners of land inherited from their fathers or other older men of the clan. They would try not to spend too long with their wives in the evenings, for fear of ridicule. Evening was a time for sitting around the fire,

Villager of the Bomai area, Southern Chimbu.

relaxing, and telling stories.

Chimbus like to tell stories and are very talkative people. Even today, village life offers little stimulation or entertainment as we would understand it. Story-telling is a form of relaxation and diversion. Their stories range from ones like that quoted on page 19, to daily doings in the village. Some might touch upon the 'supernatural'.

'Supernatural' phenomena are certainly recognised, but the Chimbus prefer to avoid them. Belief in sorcery still appears to be quite strong, particularly

when a young person dies of natural causes. When a student at Kerowagi died due to a heart ailment the thirty or so boys who had shared his dormitory cleared out of the place in no time and doubled up with their friends upstairs. They felt he had been killed by sorcery and therefore evil influences may be lurking where he had died. Their rationale is not uncommon elsewhere and their feelings about ghosts are shared by many westerners. The spirit world manifests itself in as many ways as does the so-called real world. To the Australian Aborigines it is everlasting time, and eternal 'dreamtime' where the ancestors live parallel to us and are no less real. In Chimbu, thoughts about the 'supernatural', sorcery and witchcraft seem hazy. There is an air of uncertainty when they talk about such things, a fear, a reluctance. I shall probably never know whether they would have been more willing to discuss the subject away from my presence, among themselves, though I imagine that they would.

The changes being experienced in Chimbu reflect those in the country as a whole. Undoubtedly further changes are still to come. Independence was granted in 1975, partly as a result of what is known as world opinion. Ten years prior to independence, Keith Willey, a journalist with a wide experience of New Guinea, wrote: 'A colony in an age which abominates colonialism, [New Guinea] is being prepared for self-government at breakneck speed. Prodded by its critics in the United Nations, the administering power, Australia, has taken this Stone Age survival firmly by the scruff of the neck and hurled it, willy-nilly, into the twentieth century.

'The pace of change has bewildered and frightened the people, but despite their protests against outside interference, and a faith in Australia which infuriates Asian visitors and which I found both remarkable and touching, there can be no turning back.

'The year 1964 saw the territory's first parliament established with a majority of native members. United only by a quality of commonsense which bodes well for New Guinea's future, these men, mostly unlettered and some the sons of cannibals, have been charged with covering, as soon as may be, a road to democracy that took the Western World 750 bitter years from Magna Carta.'

Well, the parliament in Port Moresby has dealt with the first few years quite adequately. It is evidence of Papua New Guinea's continuing stability that virtually no outsiders, apart from Australians, have even heard of it. There have been no massacres or coups to make good newspaper copy, and it seems to be of no strategic interest to the military powers that be. Hopefully, therefore, this extraordinary nation may continue its introduction to the twentieth century in its own special way.

[4]

School Preferred

Although western influence is reaching everybody in Chimbu, it is the young who feel it most. Primary schools abound, and what an event it is for a young Chimbu, that first day at school. He sits at a wooden desk in a prefabricated building and listens to a stranger who may not even be from Chimbu talking at him in a foreign tongue. He is given books which, initially anyway, he will treasure as sacred objects even though the letters in them mean nothing to him. The drawings and illustrations in some of the books may be arresting, though, for many youngsters, school will offer them their first close contact with such wonders. At the end of the day he will go home and tell his family all about it. His parents will be pleased if he likes school, and concerned only if he says that the teacher grew angry with him.

At the end of six or so years, most youngsters come away from primary school understanding some English, speaking a little, and writing even less. Those who have passed the necessary examinations go to high school. Of the rest, most return to the normal village routine. Perhaps these last will feel somewhat alienated, but they have had the advantage of living at home all this while, and so will be able to pick up the threads of village life again more readily than most high school 'drop-outs'. 'Drop-out' (for the Chimbus—a student who doesn't complete his four years at high school) was a term I heard frequently in my students' conversation. It was considered a sad thing to be.

For those that qualify for high school, there are five such institutions in Chimbu Province, four of them boarding schools, each with about five hundred students, and one new day school. Kerowagi High School, built in 1968, is a boarding school. High school is quite another experience. The student as a boarder rarely gets back to his home village (often several miles away) for the duration of the term. Alienation begins here. While I was at Kerowagi the terms could last up to sixteen weeks; fortunately the three long terms per year have since been replaced by four shorter ones. Students had a chance for weekend home leave every three weeks, and this was

especially popular among those seeking an opportunity to stay with friends or relatives in the nearby town of Kundiawa. Whenever I went to Kundiawa (about fifteen miles from Kerowagi on the highway) for Saturday morning shopping, I used to find what seemed to be about half the school there hanging around the stores or sitting in the sun. A horde of them would inevitably corner me and beg or wheedle a lift back to Kerowagi or somewhere along the road, creating pandemonium all the way. I liked them for it. I liked them for their easy and open bending of the school rules and I liked their good-humoured and always respectful approach to me their teacher. I also liked some of the lazy cases, but then I was never much of an authoritarian.

The contrast that high school makes with village life cannot be overemphasised. The school day is long (lessons from 7.45 a.m.–1.30 p.m., work parade from 2.30–4.00, night study from 7.00–8.30), and the mysteries of the standard Australian curriculum are great indeed. These are the subjects it covers: English, maths, science, social science, expressive arts, practical skills, commerce, agriculture and home economics. The first five are compulsory subjects right through high school. The following words, spoken by an Indonesian farmer to his student son, might I think equally well apply to the feelings of the average Chimbu father:

'You tell me schooling is very different. You sit on a chair all day in a place called school. You hold a pen in your hand and you write and speak in a strange tongue . . . your life will be very different from mine. It already is in so many little ways. Be that as it may, you must do well the things they teach you in the school or life will be hard for you. What will you do when they stop teaching you and send you home? You were never taught to be a farmer, indeed you will not know how . . . I cannot teach you these things as you have learnt other things, things I will never know or even understand. 'Tis indeed a strange place that you call school and even stranger are the things you learn.'

(*Asian Action* magazine, July 1978).

Paula Brown says how hard it is to imagine a Chimbu village father asking his child, 'And what did you do at school today, son?' And so it is. There is no point of contact—not socially, culturally, economically, or, in some cases, gastronomically. Although broadly speaking school takes place in the student's own community, it is in a medium which is thoroughly alien. The material is alien and the objectives are alien. What he does at school has little application to the average student's main interests, which are local affairs, nothing to do with school. Whenever I came across a group of students relaxing together, or entered a noisy classroom during night study, the talk

[27]

would rarely be about what was being learnt at school. Rather it would be anecdotes about things happening in and around Kerowagi station. The academically successful student (like the two who when approached during their break one afternoon said they were discussing communism, a happening so rare that I re-told the story again and again) usually becomes quite detached from the local community. Either this, or his school work is done in an entirely separate mental realm—which cannot be easy. The former type was the most common, having no real desire to return to village life, his symbol of success a white-collar job. They mouth words like 'progress' and 'development', but they do not see these things as having anything to do with expanding horizons at the village level. And who can blame them? They are not taught to recognise the needs for development in the villages. Development to them means cement buildings, smart suits and pop music. It means emulating the white man who is not a farmer, who doesn't get his hands dirty, yet always seems to be playing with a full deck.

Happily not all the educators in Papua New Guinea continue to perpetrate this colonial hangover. It is those who are not up to their job, and the scope of the job is enormous, who are the sticklers for precedent and the petty detail that is the bane of all bureaucratic systems. It is due to their shortsightedness that what began in all good faith as a system for training an academic native elite to assist in administration has become a production-line of youngsters with expectations far and above what their country can fulfil. Those who recognise the situation for what it is are hoping for chances to experiment within their schools, to reduce the heavily academic emphasis and re-orientate their programmes to more of a community bias. When I left the country in December 1977 there was some evidence to the effect that the Department of Education in Port Moresby was sitting up in bed and thinking the problem over. I wish the experimenters all good fortune.

In spite of all that, and regardless of liberals like myself going around beating our breasts about what victims of change our students were, there is no doubt that they really liked school—most of them, anyway. School as a way of life was full of diversions and weird strangers who tried to make you work but weren't allowed to beat you. The speed with which a new teacher's classroom would fill up when the bell rang was a measure of his novelty value. Of course the novelty would wear off, but still there were enough changes from day to day, unlike in the village. And there were movies and dances at the weekends, with Charles Bronson and ABBA riding the crest of the wave! The spontaneity—chaos even—that these students brought to their school life would have little outlet in the sombre cloisters that symbolise school in my mind. But that is my misfortune.

[5]

Just Drawing

I do not want to give the impression that life for the students at Kerowagi was one long jamboree. For the most part they worked well. They wanted to learn, for whatever reasons were theirs, and they took their grades seriously, almost too seriously.

The first of the four years at high school was difficult for most of them. Coming from primary school where the standard of English language teaching was not always the highest, problems of understanding and communication were numerous. For the first time in their lives they had foreign teachers—from Australia, New Zealand, Canada, Norway, Britain, the Philippines. Never before would they have heard English spoken with such a medley of accents. Their situation was equivalent, if not worse, to that of an English eleven year-old with his primary school French trying to fathom a secondary education offered by French Canadians, Moroccans, Senegalese, Malagasy, and a few *bona fide* Frenchmen.

When I started work at Kerowagi in January 1976 there were twenty teachers on the staff of whom half were from overseas. The rest were from various parts of Papua New Guinea. However, as the country trains more and more local teachers, recruitment from overseas is dropping quite rapidly.

Taking these obvious difficulties into account, along with their village background, the adaption to high school and the progress shown by the average students were, to my mind, remarkably good. An examination system still prevails and rote learning was the way to deal with this for most students (as with students everywhere maybe). Also, as with classes everywhere, every class had its small group of students with minds sufficiently enquiring to try to come to grips with subjects as a whole and to apply their learning across the board. Of these questioning and ever-curious types, many were more than equipped to hold their own in equivalent western schools. If that sounds patronising it's not meant to be. It merely answers a poorly-phrased question that I'm often asked, namely, 'Are they as

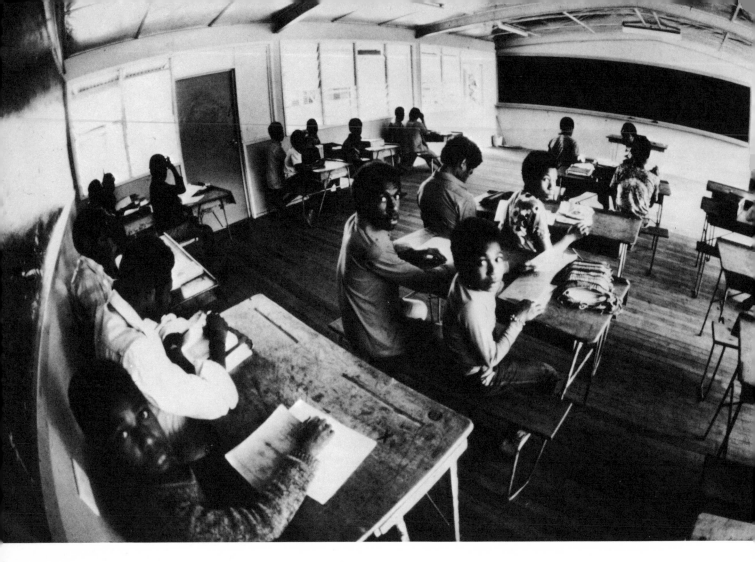

Grade 8K (Form 2) during one of our English classes. The classroom is typical of those at Kerowagi.

bright as western children?'

For most of them, major problems in understanding English would be ironed out by their second year. Speaking and writing in a foreign language usually develops later, and in that order, and their writing, except among the more academic of them, was never what I would call good, though it had a certain spontaneity and charm. I taught nothing but English during my first term at the school to the Forms 3 and 4 (now known as Grades 9 and 10). I found it rather frustrating, not being a linguist, for there was nothing to come to grips with. I did what I could without a set syllabus and meanwhile cast envious eyes at the peddlers of maths and science, the no-nonsense subjects. Art I didn't give much thought to from under my pile of English books to be marked. The art block was away from all the other classrooms and the only impressions I had of what was going on over there came from the occasional child wandering past the staff room clutching a macraméd coke bottle holder or a mobile of paper fishes. These I disdained and returned to my English books.

The teaching of art seemed to be the responsibility of at least half the staff. Expressive arts, as the subject is called in Papua New Guinea, covers the visual arts, music and drama. It is generally regarded as a non-subject. No grades are given and therefore no excellence expected. It is doled out to whichever teachers have gaps in their timetables that cannot be more usefully occupied. It is a great pity. In a country of so much artistic promise, many of the 'art teachers' are in that position unwillingly ('Oh, alright, I'll take them for a couple of periods, but what will I *do* with them?'). The teachers are less to blame than the blinkered official attitude to the subject.

There were on various classroom doors and from previous years some colourful and attractive designs applied in gloss paint. They were all of a lozenge or shield shape and some were decorated with facial motifs. By far the most striking was a series of them on one wall of the art block. The asymmetry of them arrested me and reminded me of similar designs I had seen on public buildings in coastal Port Moresby. I liked them, and wondered why all of the dull prefabricated school buildings weren't emblazoned with them.

Before the second term of that first year had got under way, a motor accident put me in hospital for a few weeks. In my absence from school a fellow-teacher, an Englishman called Mike Manhire, took over some of my English classes. I convalesced at the house of a friend who was teaching at Aiyura National High School in the Eastern Highlands Province. The National High Schools teach Grades 11 and 12 (Forms 5 and 6) and a good number of their students go on from there to university or other colleges and training institutes. The National High Schools (there are four in the country) are quite a bit more sophisticated than the high schools, and I was most impressed with Aiyura's Expressive Arts Department, particularly with what they were doing in the visual arts. Barry Ison, the head of the department, was running batik and screen printing programmes with some very fine results. What interested me most, though, were what Barry called the graphic designs. His students, who came to Aiyura from all parts of the country, were using Rotring pens (with a controlled ink-flow) to produce designs which were among the most striking I had ever seen. This applied especially to the work done by the highlands students. I bought a few reproductions of the Aiyura work and some from Sogeri National High School, where Barry had also worked. I returned to Kerowagi wondering whether our students would be capable of producing anything similar. After all, they were younger than the Aiyura students, they were almost all Chimbus, which reduced the chance of cross-cultural influences, and they were certainly not the academic *crème de la crème* of the country.

[31]

I showed the drawings I had bought to Mike Manhire and he agreed that they were very fine. Mike was teaching some art classes and I asked if he thought our students might have similar skills. 'Why don't you take some of my art classes?' he said, 'and I'll keep some of your English'. The contract was sealed and my timetable was adjusted to accommodate six periods of expressive arts per week—three with Grade 9 and three with Grade 10. The rest was still English. I never took more than ten periods of expressive arts per week during the full two years at Kerowagi. The rest was always English and it always had to take priority.

I bought some black felt-tipped pens and some white cartridge paper and with this I entered my first art class. The students were mostly aged 14 to 16 years. I talked to them a little, told them that art had been one of the subjects I had taught in East Africa, and how much I had enjoyed it. I talked about my interest in art and my feelings that artistic expression springs from visionary insights, an exploration of the self rather than a desire to decorate or to recreate nature as we know it through the cruder senses. Not much of this will have meant anything to them, and perhaps that was just as well. Perhaps art teachers should never mention the word 'art', and so leave their students' creativity to exercise itself in innocence.

I could see them looking at the pens in front of me as I held up some of the designs I had brought back from Aiyura. 'These were done by Aiyura and Sogeri students', I told them. 'I'm not asking you to copy them, just to look at them. Nor am I asking you to draw what I look like in a photograph or what your village looks in a photograph, but you may do that if you want. Draw what you like.'

The materials were handed out and most of them set to work quite quickly. I left them to it, marked some English books, and not until about half an hour before the bell was due to go did I have a look at what they were doing. They had been relatively quiet throughout the lesson and now I could see why. Bizarre and fantastic images, stranger still and with greater detail than the drawings I had shown them, were taking shape on their papers. With superb execution one boy, Areme, aged fifteen, had drawn a great hook-nosed head and was embellishing it with all manner of creatures and objects—birds, fish, shells, snakes, pigs, axes (page 81). Another, Sigl, also fifteen, was drawing a refined exotic bird with large vicious claws (page 112). Anton's bird had breasts and a head that looks strangely mechanical to me (page 104), and Musii's figure defied description (page 74). Many more equally startling drawings had been begun, all of them by boys. The girls were in a minority in this class, and in the school in general (about one hundred girls to four hundred boys), and they seemed somehow reticent

about the drawing experiment. Many had started several drawings and not got far with any of them. Some of them were half way through some attractive images, but none had the striking promise of the boys' work. I didn't give this much thought at the time; I was occupied bombarding the boys with questions—What's this? What's that? Where did you get this idea from? Is this a witch? Does this illustrate a clan legend? Why have you outlined your keys here? Why have you outlined your hand? Why has this man got a leg where his arm should be? Why, why, why. Were they thinking—as I sometimes think now in the light of my experience at Kerowagi—'Why must whiteskins always ask why?'

Whatever they were thinking, their replies to my questions were of a kind. They smiled, they shrugged, they said, 'Oh, it's just a drawing'. I asked if they had done work like this before and they all said no—'We weren't given pens like this.' 'Good Lord', I thought, 'can the muse be hamstrung for want of a felt-tipped pen?'

These were boys of whose fathers Paul Wingert had written: '[Their] implements are well-executed but have little distinction of shape or decoration', whose villages are picturesque but only in the rural sense, whose home area isn't even listed in the books on South Seas art. I asked what kind of things they had done in previous art classes. 'Some clay modelling', they said, 'models of villages, some water colour paintings'. I had seen some of their water colours lying around in the great dusty piles of detritus that accumulate in school stores everywhere. They had reminded me of the products from my own primary school art lessons, inspired by an elderly authoritarian who had demonstrated to us on the blackboard, 'This is where the sky ends and the earth begins. This is what a house looks like. Make sure it it in proportion'.

So I decided to follow the path of least interference with these students— just to let them go in my art classes, but always to give them encouragement in what they chose to do. In the months that followed, most of them chose drawing and more drawing, some of the girls included. After the initial scramble for the pens at the beginning of lessons (there was always a dash for the best materials), they would usually settle down quickly and quietly to continue their drawings or to begin new ones. Often a student would have two or three drawings at varying stages of completion. Some chose to sit outside in the sun, with their drawing boards on their knees. Some would sit inside, humming quietly or carrying on desultory conversations with neighbours. Their relaxation and obvious enjoyment of these classes pleased me as greatly as the work they were producing. Occasionally one would tell me, 'I don't know what more to do with this drawing', and I would say,

'Maybe you could fill it out a bit there'. Usually though, they just went their own way, constantly surprising me with their wealth of imagery.

They were *all* able to reproduce the natural forms common to their environment. Some of course were more skilled than others, but basically, they could all draw. The boys, that is. Of the girls, although many produced some attractive work, only one reached heights of imagination and technical skill equal with the boys. This girl, Dara, aged sixteen, was top all-round

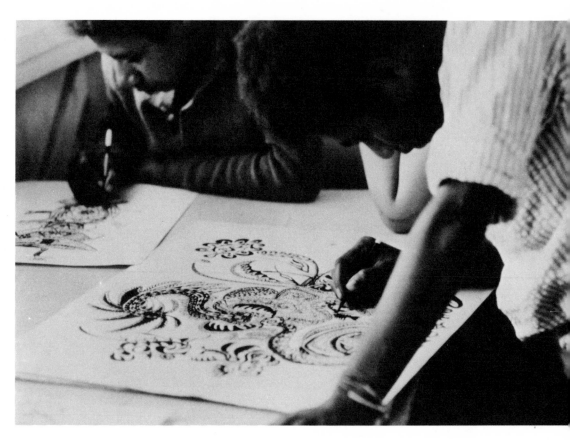

Grade 10 (Form 4) boys drawing—this was in the early days when they were using felt-tipped pens.

student of 1977. Extremely clever, analytical and shy, she always struck me as being somewhat removed from the general ballyhoo of school life at Kerowagi. She seemed to be one of those students who had detached herself completely from local concerns. This was particularly rare among the girls. Although a good many of them equalled the boys in academic prowess, basically their hearts were closer to home.

The girls' lack of enthusiasm for drawing and preference for craft work was perhaps not surprising. Traditionally, craft work is largely the women's concern in Chimbu. Furthermore, contact with the lowlands cultures grows

[34]

stronger with improved communications, and among these cultures it has long been the tradition for the men to be the decorators. In the areas where pottery is common, it is often the women who make the pots, but always the men who decorate them. Other artefacts, weapons and houses are always embellished by the men, though the women may help in gathering the necessary materials. Something of this practice has no doubt had an influence in Chimbu. Chimbu weapons, for example, when required for ceremonial

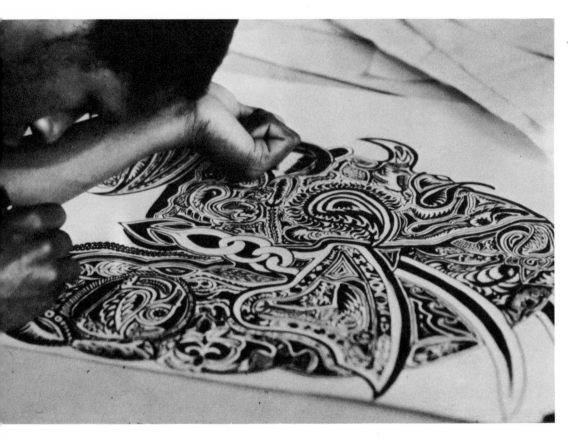

Areme Gela, aged 15, during our first classes, draws his fantastic 'head' with a felt-tipped pen.

reasons, are now decorated with some carving and perhaps woven grass, and it is the men who add these simple aesthetic touches. The women's talents are largely confined to making fine string bags, clothing, and bead jewellery, all of which they do most skilfully.

There is no doubt that recent exposure to lowlands cultures through books, films, and occasional meetings with lowlanders has had its effect on the visual imaginations of these young people. The designs on the school walls already bore witness to that. The shield and facial motifs are popular images in coastal art. Although the shield motif was not often employed in

[35]

their drawings (there are examples on page 49 and page 92), the facial motif and other figurative elements were common. The following description of Paul Wingert's was applied to Sepik art, but he may equally well be describing many of the Kerowagi drawings: 'The diversity of conventions used in the representation of facial features and parts of the human body is truly bewildering. Eyes, for example, appear as pin-points or as huge circles, as narrow slits or as wide ovals. Heads may be round, oval or diamond-shaped. . . . These stylisations appear on figures in countless combinations.'

However, very few of their drawings contained *nothing* but traditional images, unlike some I had shown them during our first class. As Chimbus, they brought their own particular interpretation to coastal constraints and as Chimbus, their lack of strong traditions left them free to explore.

The school library was a popular place. When they didn't have specific projects to research (and sometimes even when they did) a great many of the students would spend their library periods just turning pages and looking at pictures. They weren't great readers, but they loved looking at pictures. There were opportunities to study western art forms from Rembrandt to Donald Duck. Rembrandt, they were positive, took photographs, but the spirit of Donald Duck emerges in the drawings from time to time (page 110). They were also *au fait* with such western refinements as shading (the dog's nose on page 76 and the eggs on page 114; other examples are pages 57, 84, 105), and perspective sometimes played a part (page 97). No doubt a great many influences were bearing upon their minds, but to minds without any strong artistic norms to bind them the resulting synthesis carried its own unique stamp.

Leaving aside the influences upon them for a moment, and looking at things from the standpoint of that great western cultural force, the liberal arts graduate, where on earth did they learn to draw like that? I had 'taught' them nothing. They told me their previous art teachers had 'taught' them no drawing. They could have been telling me a story—but why bother? That wasn't their way when they weren't in trouble. And they weren't in trouble here. They found my enthusiasm either amusing, or touching, or embarrassing. 'I'm just drawing' I heard again and again. It was the truth, too. When a friend arranged for a journalist from Papua New Guinea's national daily, *The Post Courier*, to come to see their work, he, an Australian, asked all the usual questions. He later wrote: 'Talk to the children and you realise they have little idea what their drawings will eventually be like, apart from a basic notion that they might picture a bird.

' "We just imagine something then build up from there," said Waim Tokam, aged sixteen. . . . "No, I hadn't done any drawing before this," he

said.' That pleased the students enormously. They had cornered the front page of the highlands supplement.

I had some original-sized prints made of six black and white drawings and profits from the sale of these kept the Expressive Arts Department well equipped for two years. We bought Rotring ink pens with tips of varying degrees of fineness and several different coloured inks. The felt-tips now lay abandoned.

When a friend who was also teaching some art at a high school in the Western Highlands Province came for a visit to Kerowagi he grew quite enthusiastic about the drawings. He later supplied his own students (mostly highlanders) with felt pens and asked them to draw what they liked. They, too, produced work of surprising refinement and imagery, work of a sort they claimed never to have attempted before. Unfortunately their teacher, an Englishman, left the country shortly after this and I lost contact with that 'experiment'.

The students were very dependent upon the encouragement of teachers. Mike Manhire, the teacher who had swopped some of his art classes for my English, later went to teach at Brandi High School in the Sepik Province. Most of his students were local, and we were interested to see how drawings by Sepik students would compare with the Kerowagi ones. Mike wrote to me: 'About the highlanders' greater creativity as contrasted to the coastals' clinging to tradition—basically you're correct, I suppose, but I think that sometimes traditional styles are maintained out of habit rather than lack of imagination. Given encouragement some of these students did produce imaginative work (pages 91 and 119). Probably they are not often stimulated to turn out anything creative, so they stick to the forms they know. Certainly there is plenty of traditional work here (the majority of drawings are in Sepik style), but also some that are quite different. Moreover, I don't think any of the Brandi students quite approached the best of Kerowagi. Overall the year's work has been, I think, very good, but more traditional and less creative than at Kerowagi. *But* it has also been more creative than in previous years.'

With little else but encouragement and suitable materials, young Papua New Guineans, particularly highlanders, were displaying what seemed to be an innate ability to produce drawings that would have western art colleges clamouring for their enrolment. With us it is a basic tenet that artistic skills must first be taught and then, if promise is shown, polished up at art college to make them commercially viable. Nobody suggests that artistic vision must first be taught, but then people concerned only with the economics of art rarely have much truck with vision. Some people to whom I have shown

the drawings have gone into minor rages when I pointed out that the childen weren't taught—that is, in our sense—'What do you mean, they weren't taught? You must have taught them something. Either that or these drawings are traditional. Nobody draws just like that.'

I wonder. If we were free from the you-can't-do-anything-without-training lobby, and with the word 'art' struck from the language, I wonder what an entirely innocent approach might bring out in our own young people?

[6]

From My Imagination

The centre of the drawing on page 65 is a perfect form of a cow, drawn by a thirteen year old boy. The one on page 70, by a sixteen year old, is based around the form of a cricket, and the figure on page 59, the work of a sixteen year-old, is a striking likeness of a Chimbu warrior. Watching my students begin their drawings, I was always impressed by the ease with which they could reproduce natural forms—cows, pigs, dogs, men, plants, insects, fish. Never did I see any of them copy anything, either from books or from one another. Somebody once told me the drawings looked as though they were all done by the same artist. I see his point; there is a sameness about many of them, and this sameness is in their wealth of detail. He was confused by it and refused to look into it, just as people who close their ears to the intricacies of Baroque music think that one composer sounds much like another. But to take the time to look into these drawings and explore the detail is to recognise their individual differences, and they are numerous. The disjointed bodies (pages 58, 80, 90, 99), the decorative banner (pages 58, 61, 74, 90), the stencilled figure (82, 101, 116, 120), the decorative border (59, 68, 74, 80, 96, 102, 113, 114): these, along with the overwhelming tendency to decorate images profusely, are the similarities.

Many are very bizarre, but the bizarre aspects cover a wide range, from the lady wrapped with the snake on page 97, to the demonic and partly Christian-influenced image on page 85; from the head on page 81, to the extraordinary balancing act on page 95. I am sure that certain of their legends and stories were the initial inspiration for some of the work. If they were, then the students either truly did not realise this, or they were unwilling to discuss it. Normally very talkative, they would simply say, 'It is from my imagination'. Admittedly I never pressed them on this point. I had read some very sophisticated explanations accompanying drawings by Sogeri National High School students most of which were not very relevant to the drawings. I didn't want to encourage the Kerowagi students to dream up explanations to satisfy my questions. John Fowles, author of *The Magus*,

[39]

writes in the foreword to that novel about being expected to have explanations for his work: 'Novels . . . are not like crossword puzzles, with one unique set of correct answers behind the clues—an analogy ("Dear Mr Fowles, please explain the real significance of . . .") I sometimes despair of ever extirpating from the contemporary student mind.' I feel the same may apply to visual works of art.

David Lasisi, Papua New Guinean artist and writer, was also responding to questions he considered irrelevant when he said, '. . . people may think that the direction of the articles and designs is an attempt to illustrate experiences one has gone through. Friends it is not as that. What this crap is all about, is searching into something that establishes one with an identity'. Or, to put it in the words of Dr Leo Navratil, 'Primarily, artistic creativity . . . serves the purpose of finding the ego, and through the ego, of establishing a relation to the world—even if this aim is not always attained'.

I had told the students that true art was an exploration of the self and yet I had forgotten that myself in my eagerness for 'a set of correct answers behind the clues'. I gave up asking questions and found satisfaction simply in watching them work.

Their method of work intrigued me as much as its results. They rarely used pencils or rubbers. If there was to be a central form—a cow or a pig—they would draw it straight away with pens, easily, quickly, like cartoonists, and rarely looking up from the paper. Then they would begin to embellish. Perhaps the pig would sprout wings. Then the wings would be embellished. Then, from that embellishment perhaps a few spider webs would trail, and so on. It was a form of doodling really. They were quite intent on their work during execution, and yet so nonchalant about the product once it was finished. Not once in two years did I see a student hold up his finished drawing to look at it, as a western artist might do. Nobody ever pinned his drawing to a wall, stood back from it, admired it or criticised it. Once it was finished, it was forgotten—literally. I found myself running around picking up superb pieces of work that had been discarded while my back was turned—dusty and trodden over on the floor, screwed up in the dustbins, lying outside in a rainstorm. Often I would approach them with a crumpled masterpiece in my hand and ask, 'Whose drawing is this?' only to find that the genius responsible either could not be bothered or was too busy with another drawing to answer. They knew I didn't punish them for throwing their work in the dustbins. I suppose they thought claiming credit for a drawing was irrelevant. It was *doing* it that mattered. Clearly to them drawing had some significance other than to decorate walls. There is a comparison here with the Australian Aborigines of Arnhem Land in northern Australia.

Their paintings on bark are governed by totemic considerations and are of no interest as a product. Finished pieces of bark are abandoned. It is the *process* that concerns the artist.

Only once did I try to direct a class in what they drew. Knowing how skilled they were at drawing their own country's animals, I showed them some pictures of African animals in books from the library. We talked about the animals for a while and I suggested they might, if they wished, base their next drawings on what they had seen. I put the books away and we returned to the art room. Some chose to experiment with this idea, and of the results, by far the most remarkable was that of Kuglame Ire's, aged fifteen, shown on page 94. During three years in East Africa I had never seen a rhinoceros rendered quite like that. In fact, I find a good deal of African art rather poised and stylised, but that could be because most of what we see of African art is geared to international sales.

Towards the end of 1976 we extended our activities with the help of the profits from the sale of prints. We began batik and screen-printing programmes, painting in water-colours, and decorating the school. To these activities the students brought all their expertise and patience, and they displayed great skill in mastering the new techniques. Batik involves a lengthy process of building up a design on cloth by the principle of the exclusion of dyes from certain areas with wax. For screen printing, a stencil of the design must first be cut from special film, a technique involving great precision, and a screen built to hold the stencil before printing on cloth or paper can begin. I needed to show them these processes only once, and they were eager and equipped to begin. The girls, too, showed more enthusiasm for these activities and they produced some fine work. The designs drawn by both girls and boys for batiks and screen prints were inventive, though larger and with much less detail than the drawings.

We bought plywood and cut it to various sizes for painting on in water colours. There was great interest in this idea, and to these paintings they applied the freedom of expression and the refined craftsmanship that characterised the drawings. Once again, although they generally used very thin brushes, it was not possible to bring the detail of the drawings to this new activity, but the results pleased me enormously. Here they made more exciting use of colour than they had in the drawings, with unheard of combinations that startled before all else. There was no comparison between these paintings and the ones I had seen in the store room at the beginning of the year. Likewise, there was none between the new paintings they were applying to the still-vacant school walls and the wall paintings from previous years. The earlier paintings were attractive but highly stylised after the

coastal fashion. The new ones blossomed with fantastic arrays of creatures and plants that were not contained, but spread over the walls, somehow utilising the nature of the buildings.

Decorating the school required much more direction from myself and Mike Manhire than any of the other activities. The clamour for as many gloss colours as a student could get for his 'team' at the beginning of the sessions needed careful control. But to stand in the middle of the assembly ground,

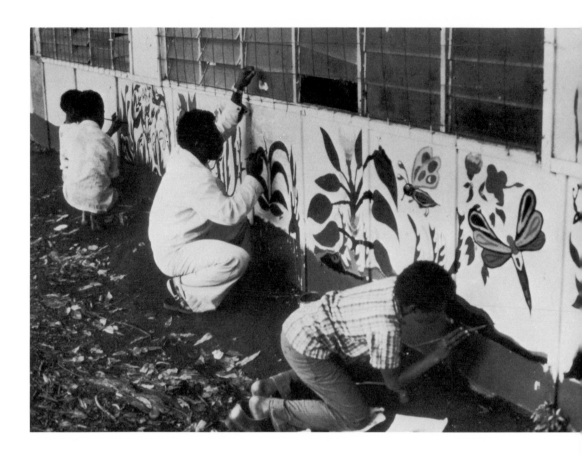

sizing up the situation, discussing with team leaders the desirability of a tree up a particular drainpipe, a bird swooping over the science laboratory, fantastic fruits and flowers growing up from ground level—that was one of the most exciting of experiences in my short career as a teacher.

They would denude the art room of tables and stools, leaving a few for those students still drawing, pile them precariously against the prefabricated walls, climb to the top, and set to with their pencils. They were fine climbers and there were no accidents, but to be able to produce what they did under

such circumstances surprised me. They would sketch out a design from top to bottom; again, no sizing-up, no standing back and thinking about it first. Then the team would move in with the various colours and things would begin to take shape. The full impact of the results cannot be reproduced in a book. The school was an extravaganza.

By now I had taken on a few more art classes, and the ages of my students ranged from twelve to sixteen years. All were involved in the activities I have

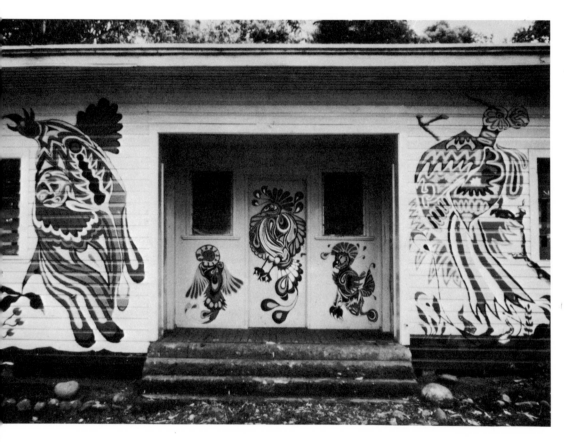

My art store-room (centre) and two of the art block classrooms, decorated by various students from Grades 8–10 (Forms 2–4).

described and among the youngsters many were showing great promise in all fields and some were equalling the performance of their older comrades.

We attracted the attention of the local community through the sale of prints and by opening up a display room in the school grounds. The room had once been the library, now succeeded by a larger building. It was ideal for our purposes. There we displayed the drawings and any reproductions, the paintings, batiks, screen-prints, and the bags and jewellery that some of the girls had made. Everything was for sale, and we always had just enough

[43]

money to finance our programmes. While some people came to buy, many more came just to look, both at the display and the school buildings. One memorable afternoon a busload of retired American schoolteachers, on a tour of the country, arrived. Great was the excitement—'The tourists are here! The tourists are here!' Tourism has touched Papua New Guinea only lightly, and our students were not used to such sights.

Many of the local people in Kerowagi and the Papua New Guinean teachers greatly admired the work the students were doing, and were especially keen to buy the batiks and screen-prints. The unbridled enthusiasm, however, came from the expatriate quarter. It was to the Europeans living in Papua New Guinea that we sold most of the original drawings and the prints. The sales didn't seem to impress the students one way or another, although I did notice that a few who were commissioned to do drawings by other teachers or friends outside the school did not produce work of their customary originality. More often than not, they would repeat something that had already been admired, just as the coastal people are reproducing their traditional pieces for sale.

Neither were they greatly impressed when, as a result of sending a few drawings to the Commonwealth Institute in London for its forthcoming Young Artists of the Commonwealth Exhibition, I received a letter from Mr John Callander, the Chief Education Officer, which began: 'Thank you for your letter of 2 March 1977, and for sending us the set of remarkable drawings from your school. They will all appear in the exhibition and I intend to use one of them to illustrate the Private View Cards. . . . Unless I am very much mistaken, this work will arouse considerable interest and comment, and I am very grateful indeed that you took the trouble of sending it to us.' Later, following the exhibition, Mr Callander wrote: 'The reaction to your students' drawings was universally one of astonishment and admiration.' A further letter, from Papua New Guinea's Acting High Commissioner in London, Mr Frederick Reiher, stated: 'I am pleased to forward Certificates of Merit . . . for Joseph Augustine, [page 67] Sigl Dorugl, [page 112] Musii Sau, [page 74] Areme Gela, [page 81] Anton Kaile [page 104]—all from your school. . . . I as your representative in London am thrilled and proud at the wonderful performance of your students, and would like to join the Commonwealth Institute in congratulating and wishing the recipients of the certificates all success with their talents.'

I think the students were pleased that Mike and I were pleased, but it seemed to mean little to them apart from that. They have little concept of life overseas, and the admiration of people they had never met was nothing to get excited about. The tourists were different, they were here and now.

Of the Grade 10 students leaving the school at the end of 1976, one boy

tried for and was accepted for a scholarship at the National Arts School in Port Moresby. Later, when I visited the arts school, a lecturer told me that he was one of the best students. The boy, Joseph Augustine, seemed keen on what he was doing there, and was eager to show me around the photographic department, the textile room, the studio for sculpture, and all the other areas he was now so familiar with. He thought he would probably take up a career in design work of some sort. I doubt he would have difficulty finding work in one of Papua New Guinea's fast expanding towns. Other Grade 10 students who had been among the notable artists were varied in their choices—national high school, medical or teacher training, the priesthood, business studies, office training.

When I left Kerowagi at the end of 1977 four boys were planning to apply to the National Arts School, and I helped them put their portfolios together with mixed feelings. Their wild imaginations could bring great originality to whichever activities they chose to pursue, provided that professional training does not stifle that very thing it was designed to develop.

Of those students with whom I am still in correspondence, Timothy (page 53) and Dara (page 80) are now at national high school, Sigl (pages 84, 93, 112) is at university in Port Moresby and Taklmba (pages 76, 86) is at a seminary. At present none of them is planning a career in art, although Dara intends to develop her talents at evening classes.

Because of the school's record in expressive arts, and due to having a helpful friend at the CUSO (Canadian University Service Overseas) office in Port Moresby, a Canadian art teacher was assigned to Kerowagi when I left. One of the main problems in education in Papua New Guinea is the high mobility of teaching staff, even among the local teachers. I was glad, therefore, that Karl Mackeeman was being assigned specifically to take over the expressive arts department.

In November 1979 he wrote to me: 'During the International Year of the Child, Kerowagi has distinguished itself abroad with three awards (one gold and two silver) in an exhibition of children's art in Tokyo, Japan. The work was chosen from 11,738 other entries from 68 countries.'

[7]

The Cultural Limbo

What gave rise to the remarkable skills and even more remarkable imagery that the students of Kerowagi High School and so many of Papua New Guinea's young highlanders bring to their drawings? It is my belief that they do not interpret their culture in their work, though they may draw upon ideas and images from it. Their work bears no academic stamp, as does art which conforms to an agreed formula of 'beauty', or clan considerations, or totemic significance. There is no loyalty to heritage or to such constraints as proportion or perspective. And it is precisely this which gives their work its force. It is also precisely this which makes the work so alien, so bizarre, to culturally conditioned western eyes. Many people have responded to the drawings by seizing upon the things they can recognise as 'pretty', as people do when faced with a novel, and therefore unsettling, work of art. It is a cosy enough attitude, but the real challenge, the spiritual and intellectual challenge, is presented by that which is different, unheard of, startling.

It is a challenge which culture is generally slow to take up. In his book *Outsider Art*, Roger Cardinal has this to say about the stifling effect of strong cultural conditioning on art: 'Culture selects, filters, reduces, sterilises . . . the reliance on the word "beauty" [is] guaranteed to strike fear in the masses. In our culture, beauty is defined with respect to a norm whose "objective" necessity is justified by hypocrisy and convention. . . . The flourishing of cultural labels has the effect of blinding the public to the actual products on show, to a point where . . . *art culturel* has become the opium of the people. Worse still, culture deadens the creative instinct in people, for if they have culture thrust at them all the time they will feel hampered when it comes to expressing themselves naturally; they reach a point where they feel that to create art is necessarily to "put on a performance" along set lines. Art informed by individual caprice appears illegitimate, and so those unskilled in the techniques nurtured by academicism, that is to say the greater mass of people, feel that art is something that can only be produced by the trained professional—any untutored activity being suspect or "mad".'

Individual caprice was in evidence at Kerowagi among young people who were living half-way between the traditional and the western. From their standpoint in this cultural limbo, they had no reason to feel hampered when it came to expressing themselves naturally, no need to 'put on a performance'. They drew just as they had told me—freely, from their imaginations, without constraint. Their work had no social function, it was not addressed to anybody in particular nor was it done for economic gain. Its chaotic exuberance and its

Village near Bomai, Southern Chimbu.

energy are released from a near-instinctive level of existence which is the very antithesis of culture. This, too, is the level of truly visionary and religious experience, having little to do with 'worldly' concerns. It is a part of ourselves that generally gets short shrift, and when visionary artists, 'mad' men, holy men and children rise up to remind us of it, they generally get short shrift too.

That the work of the highlands children in those schools with which I had contact was generally the most original leads me to conclude that Roger Cardinal's analysis of the stultifying effects of culture upon art is correct.

[47]

Chimbu villager (near Kundiawa).

Thirty years ago Paul Wingert observed that what made New Guinea 'an important centre of Oceanic art' was the well-developed styles of the lowlands people. Well, these cultures still have not shaken off the constraints of their now fossilised well-developed styles. Among their young people, it is mainly those who are actively encouraged to do so who are finding a new means of expression.

In the highlands, the vocabulary for the new means of expression is one of cultural innocence.

Dinoge K, aged 11. Very much in the tradition of coastal art to which youngsters get quite a lot of exposure through their primary school books and teachers. (55 × 40 cm)

[48]

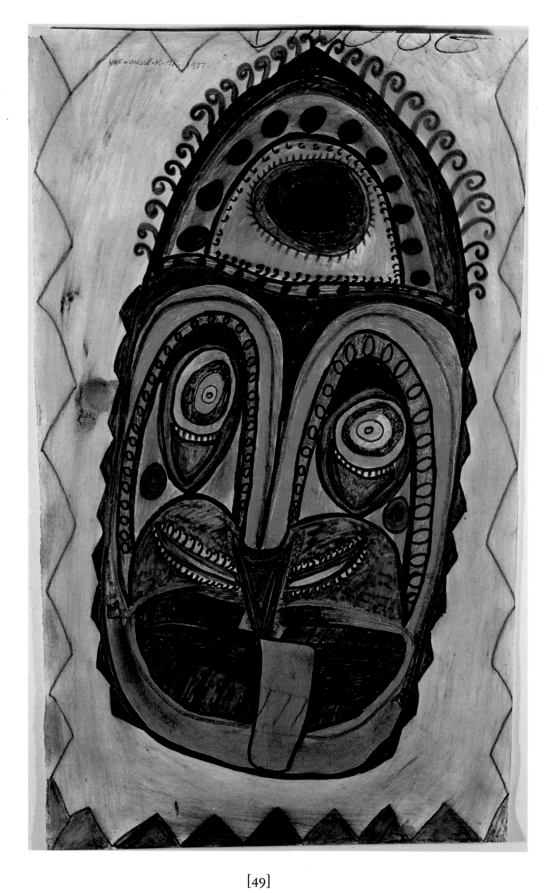

[49]

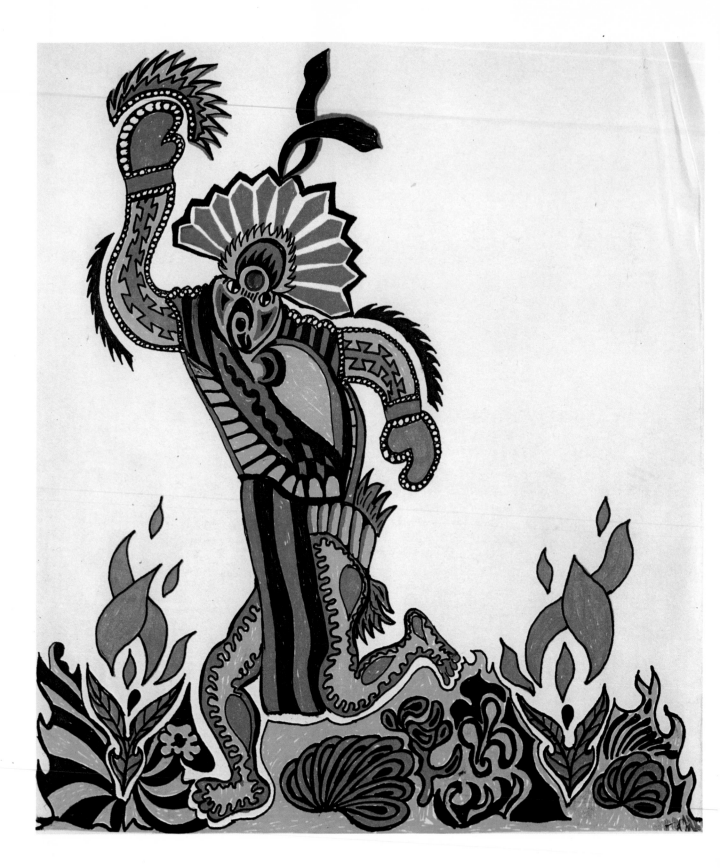

Kum Wamugl, aged 13. An individualised version of Chimbu traditional dress featuring the
pulpul *(woollen apron). (30 × 25 cm)*

Opposite: Kawage Gagma, aged 15. Hunter and kangaroo. (40 × 33 cm)

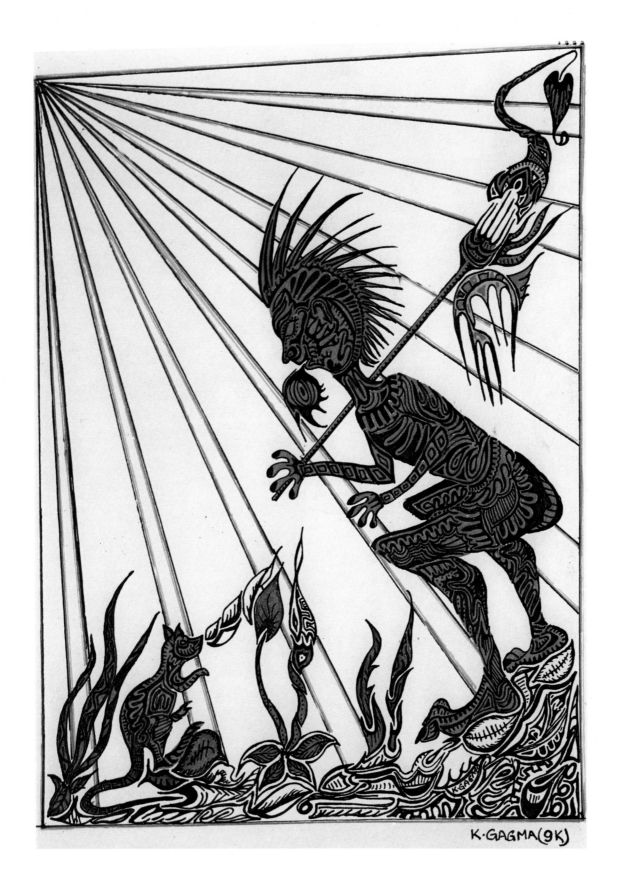

K·GAGMA(9K)

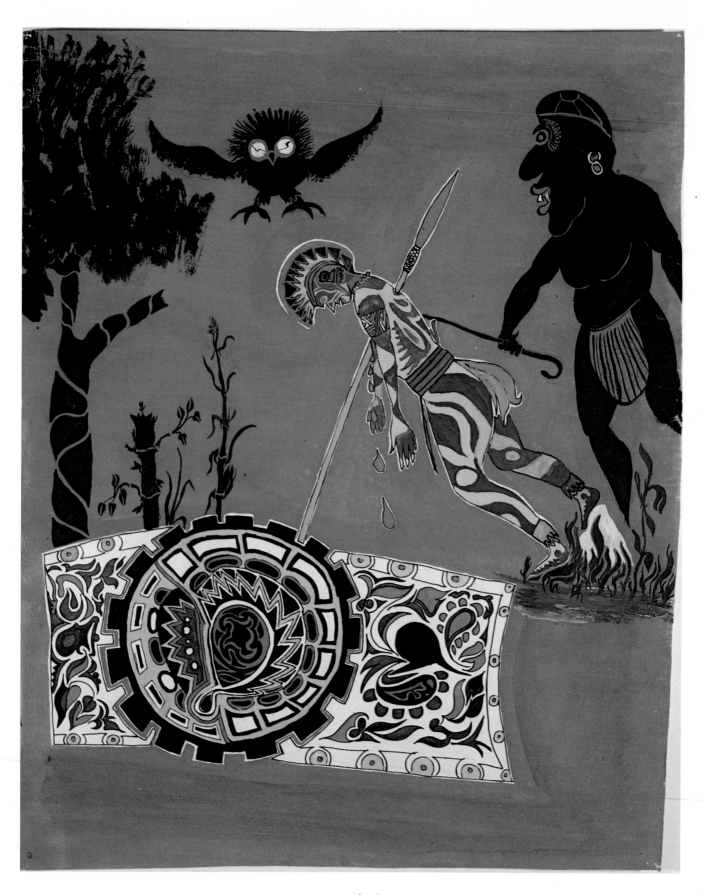

Timothy Komane, aged 16. It took Timothy several weeks to complete this, drawn entirely with Rotring pens. The style is unique among the Kerowagi drawings and the western influence strong. Timothy went on to Aiyura National High School. (55 × 40 cm)

Opposite: Henry Gioven, aged 13. Water colour. (55 × 40 cm)

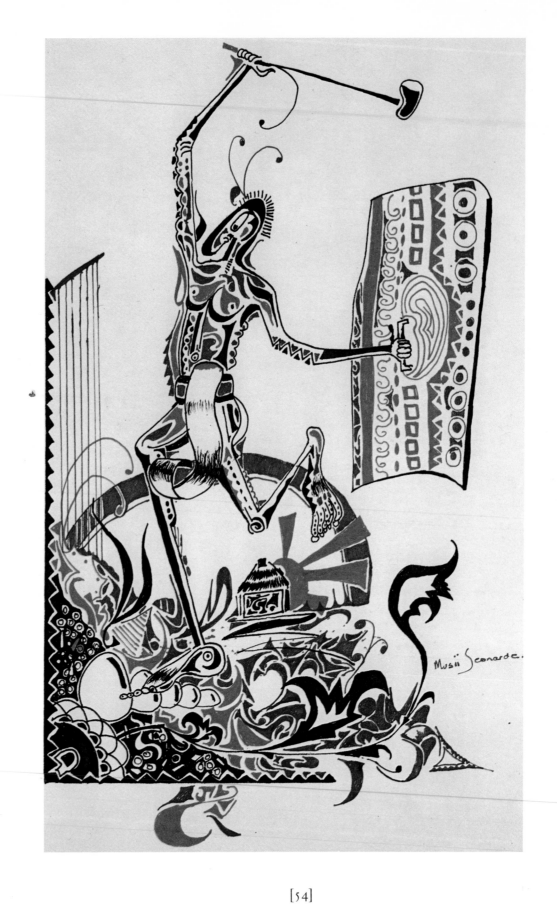

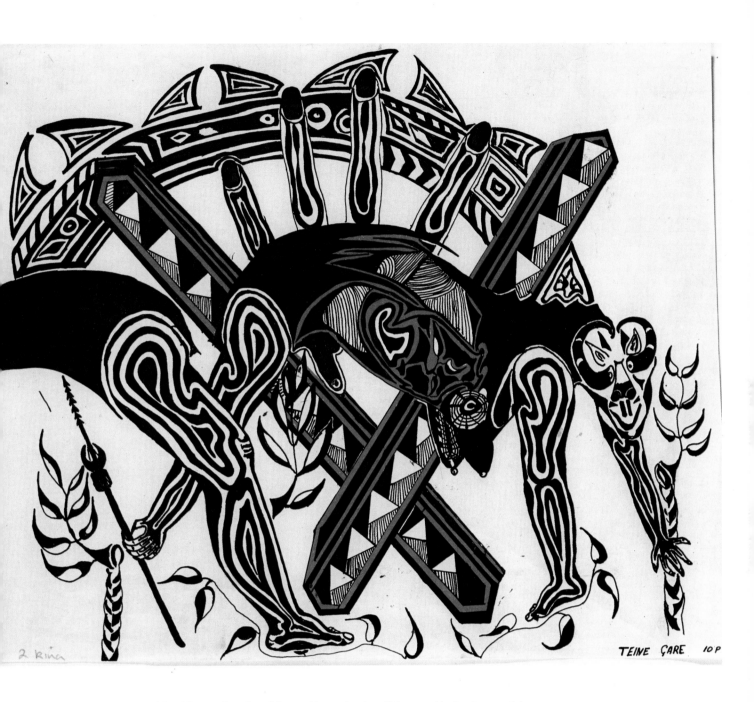

2 Rina

TEINE ÇARE 10 P

Teine Gare, aged 15. One of the most bizarre drawings. Teine started by drawing around the
fingers of one hand. (45 × 35 cm)

Opposite: Musii Sau, aged 16. Warriors featured a great deal in Musii's work. He worked
very rapidly, without using a pencil; this drawing took about two hours to complete. Musii
often signed himself 'Leonarde'. He went on to university. (55 × 40 cm)

[55]

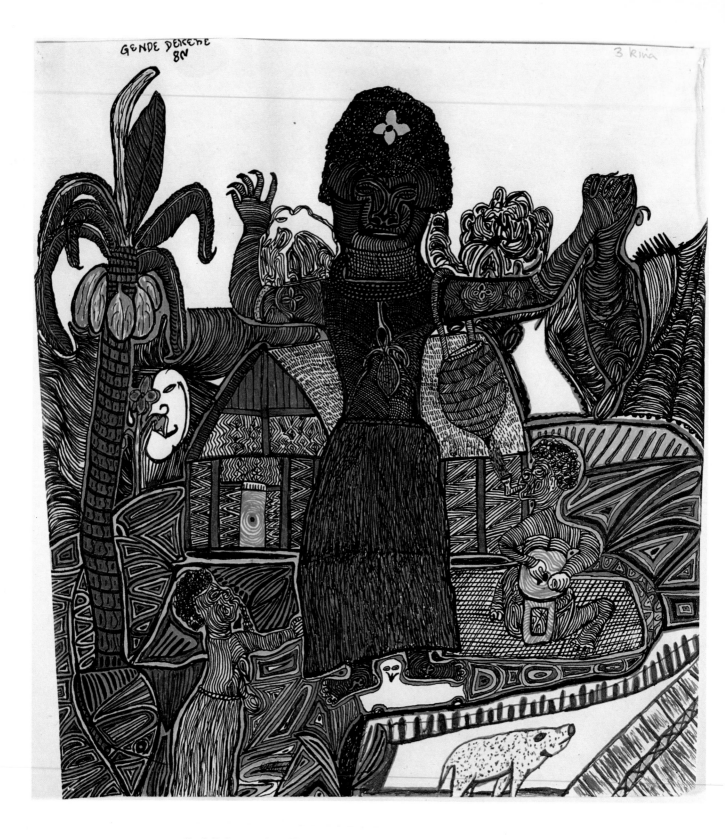

Gende Dekene, aged 12. Western influenced, the idea of a 'picture' is strong, although balanced by highly decorative elements. (45 × 35 cm)

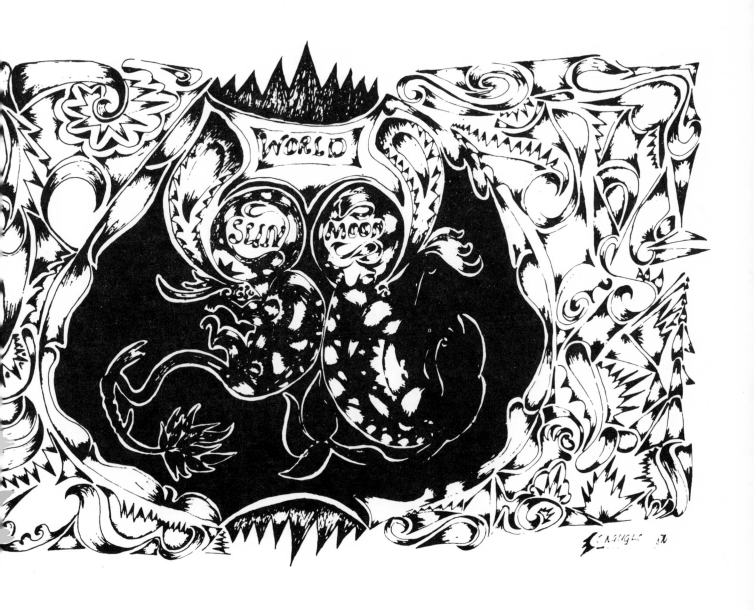

Onguglo Golka, aged 12. This boy's style was very individual, always with a great deal of scrollwork and shading.
(55 × 40 cm)

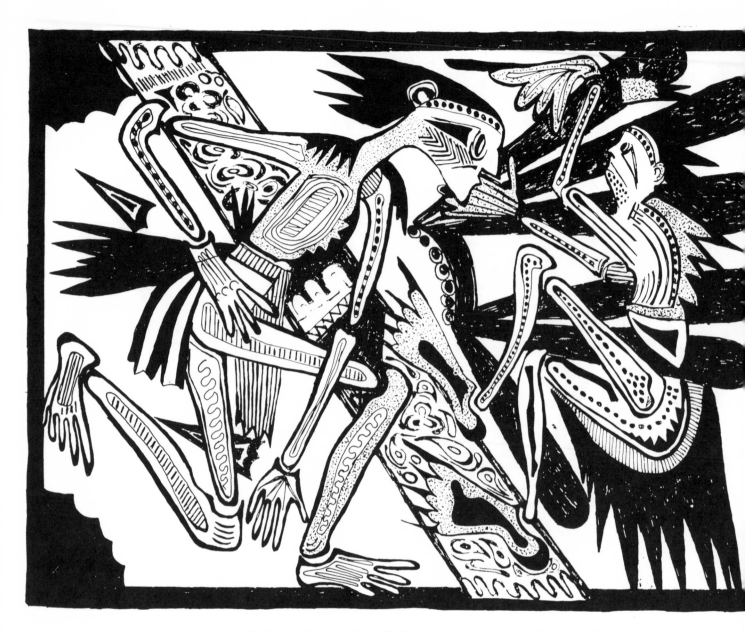

Ager, aged 16. The decorative banner and disjointed bodies are images common to several of the drawings. (45 × 35 cm)

Opposite: Musii Sau, aged 16. The Chimbu face is perfect. Musii's work often incorporated the part-border to fine effect. (55 × 33 cm)

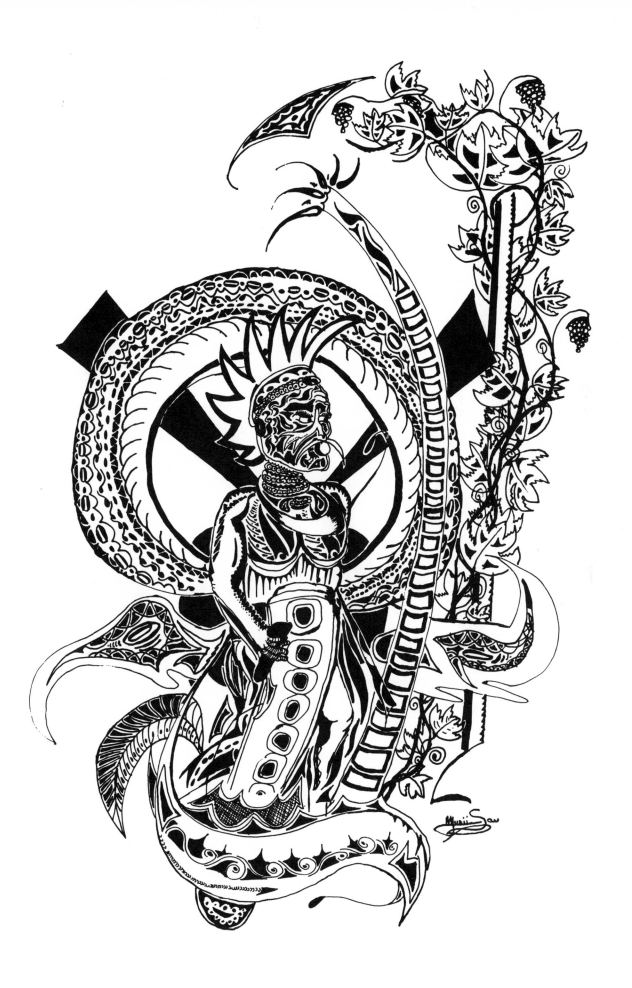

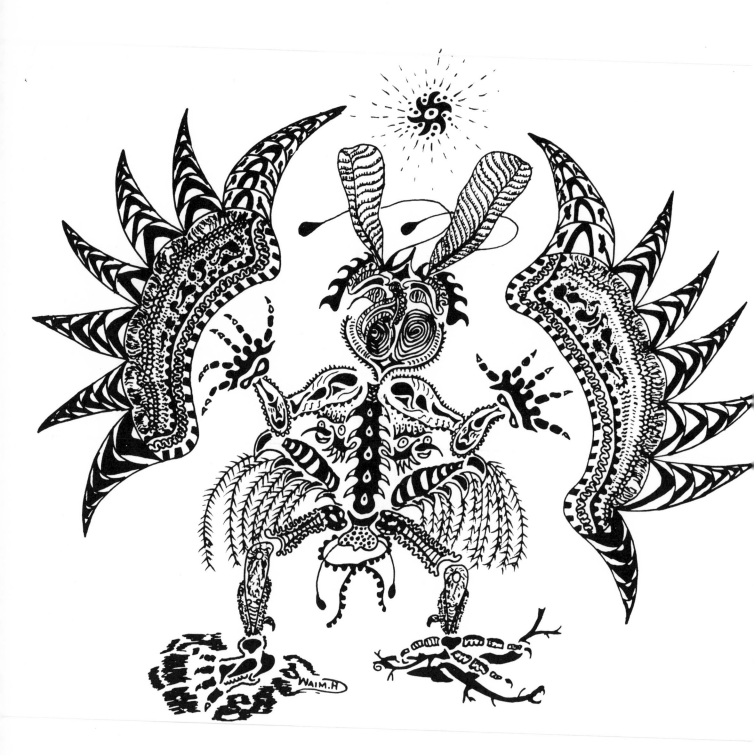

Waim Tokam, aged 15. Waim's work grew more and more complex; compare his drawing of a year later (page 106).
He went on to university at Port Moresby. (45 × 35 cm)

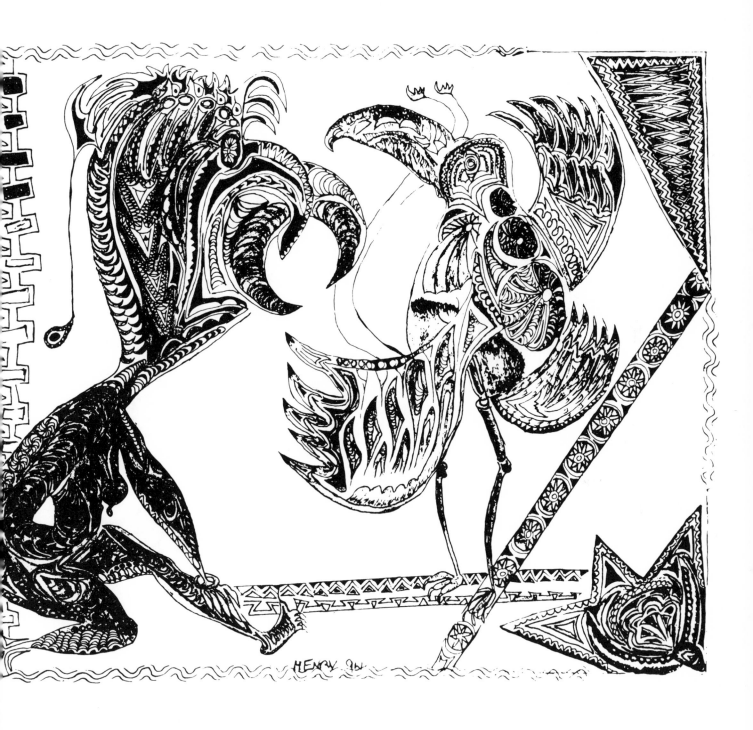

Henry Gende, aged 15. All of Henry's drawings featured birds (55 × 40 cm)

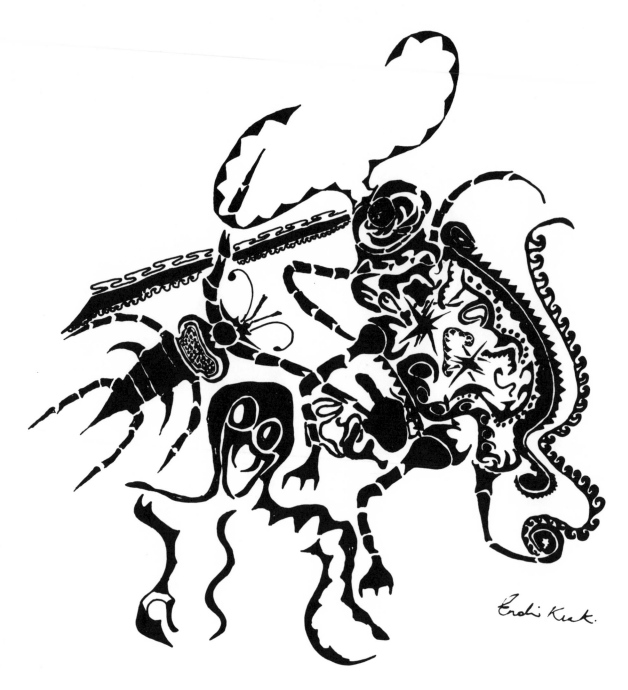

Endi Kiak, aged 15. One of the few students who volunteered information about his drawings, Endi said this one showed insects fighting. (45 × 35 cm)

Opposite: Waiange Gerel, aged 15. Notice that he has outlined his keys. Such 'unsophisticated' devices were common. (55 × 40 cm)

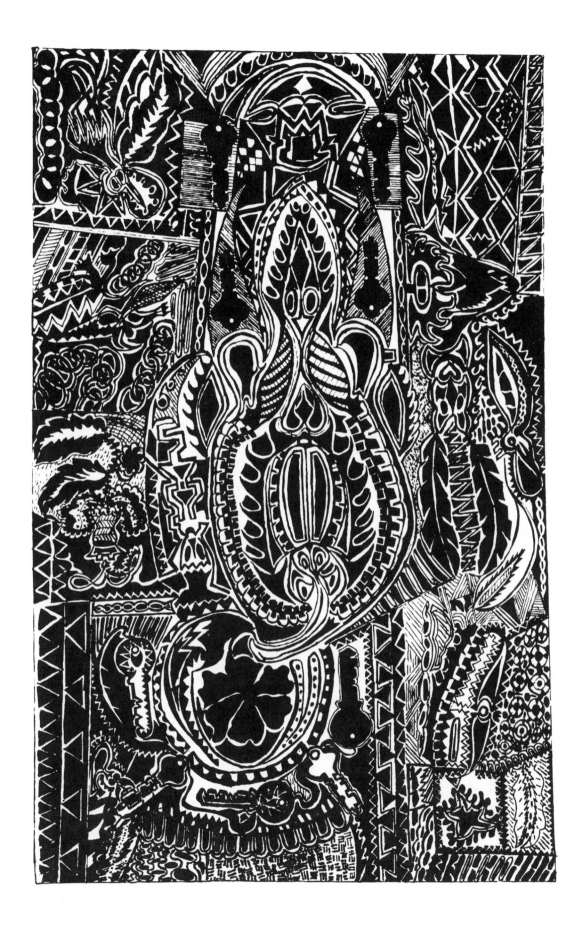

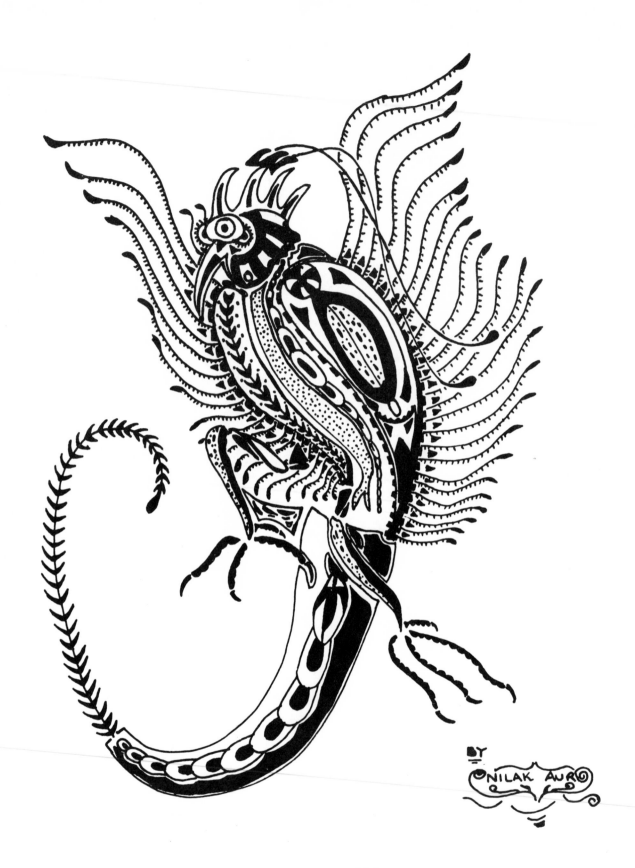

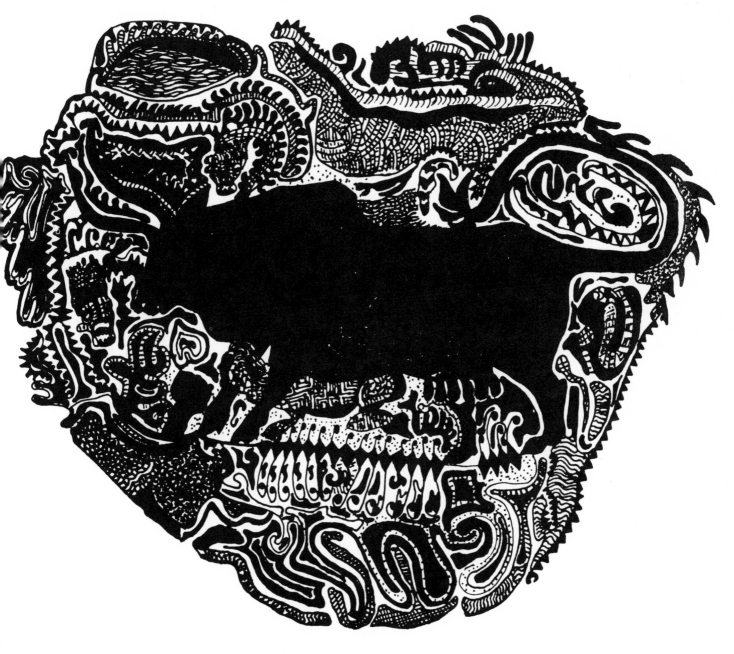

Nulai Nebare, aged 13. The image of a cow is almost Cretan. (40 × 35 cm)

Opposite: Nilak Aur, aged 15. Nilak's style varied from this (one of his first) to those on pages 71 and 107.
(45 × 35 cm)

[65]

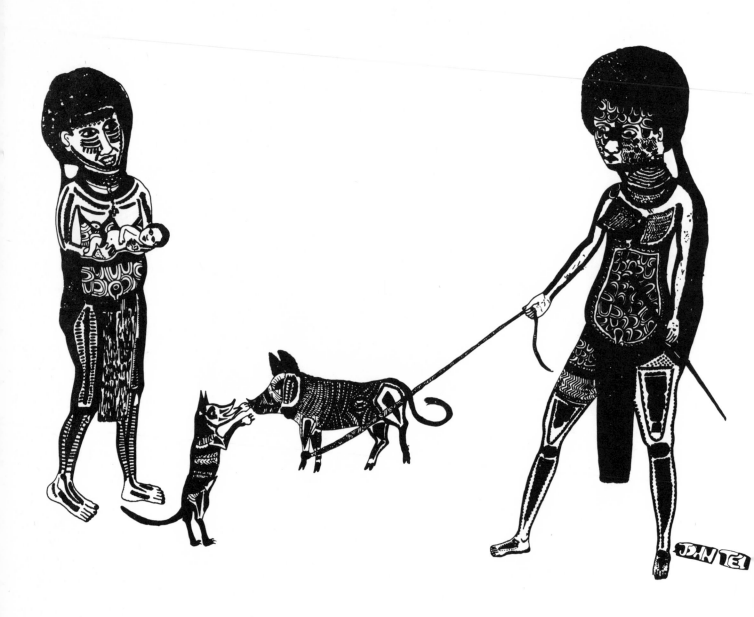

John Tei, aged 14. Two Chimbu ladies. Pigs are frequently seen on leashes. John loved to draw and was very prolific. He was not interested in any of the other expressive arts activities. (60 × 45 cm)

Opposite : Joseph Augustine, aged 16. Joseph won a scholarship to the National Arts School. This drawing was used to decorate the Private View cards for the Commonwealth Institute's exhibition of work by young Commonwealth artists in 1977. (40 × 33 cm)

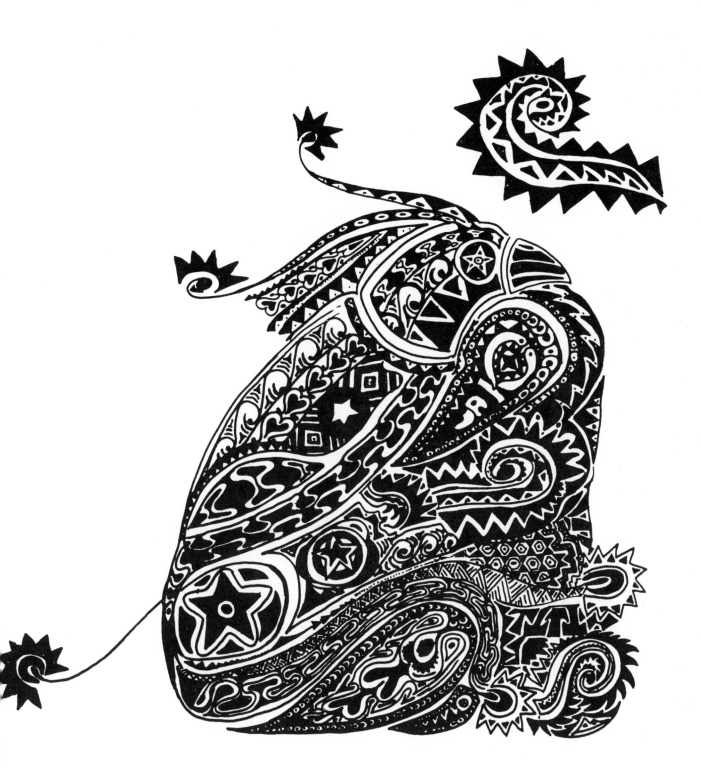

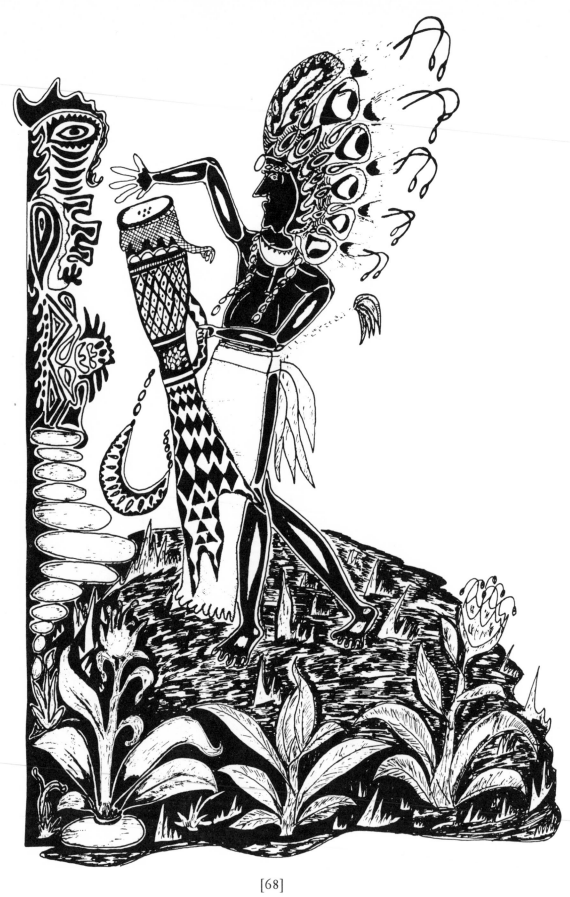

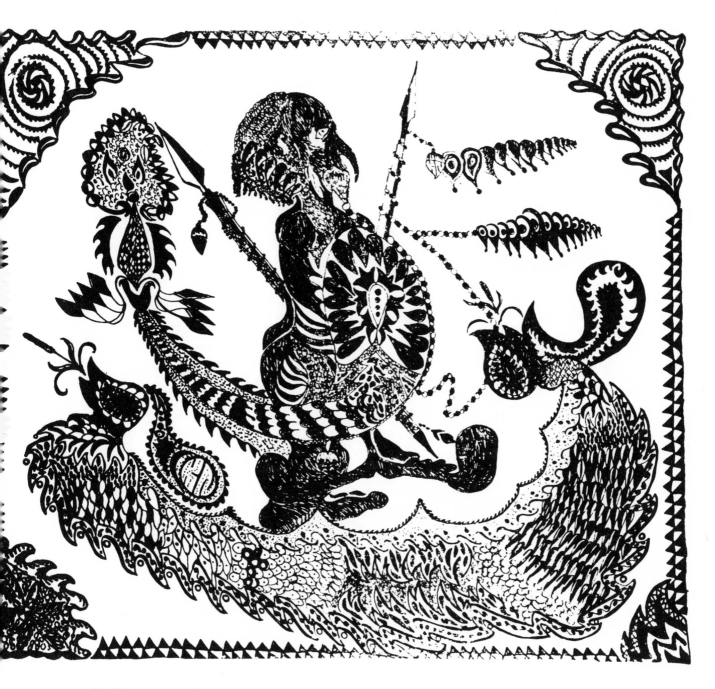

Kagl Nombri, aged 13. Warrior. (45 × 35 cm)

Opposite: Kuglame Gabe, aged 14. (40 × 35 cm)

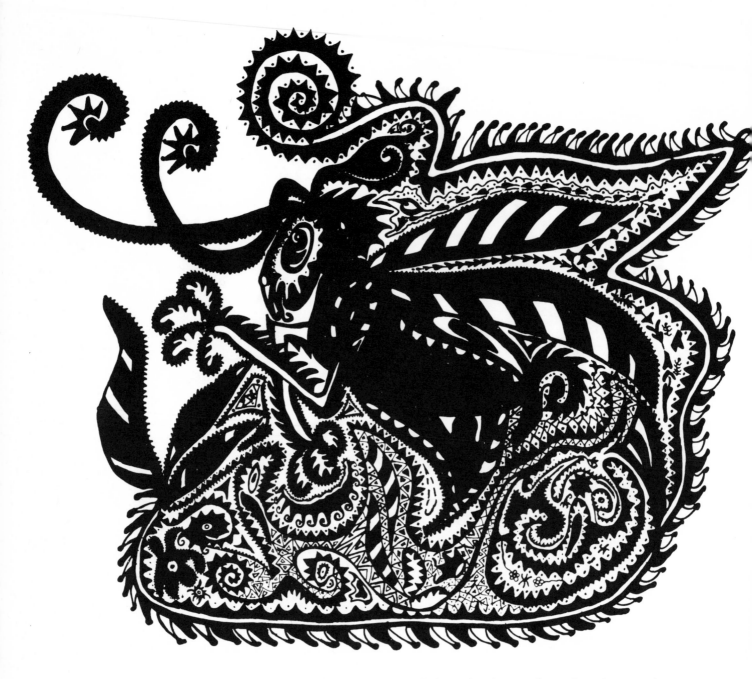

Andrew Gagma, aged 16. One of the drawings begun with felt-tipped pen during our first art classes. (45 × 35 cm)

*Opposite : Nilak Aur, aged 15. This one was inspired by a picture of an oriental painting that he had seen previously.
(55 × 40 cm)*

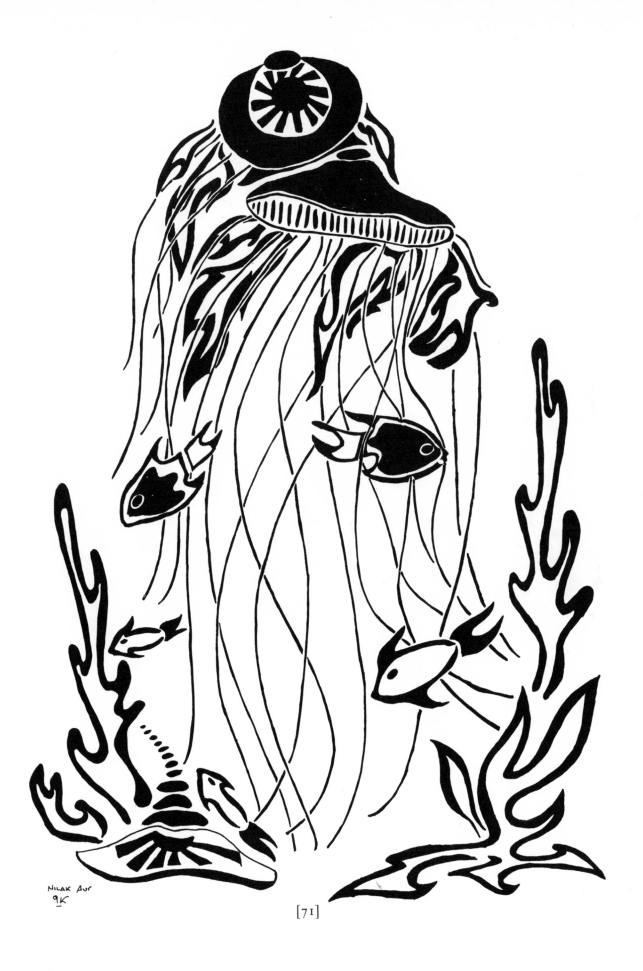

NILAK AUR
9K

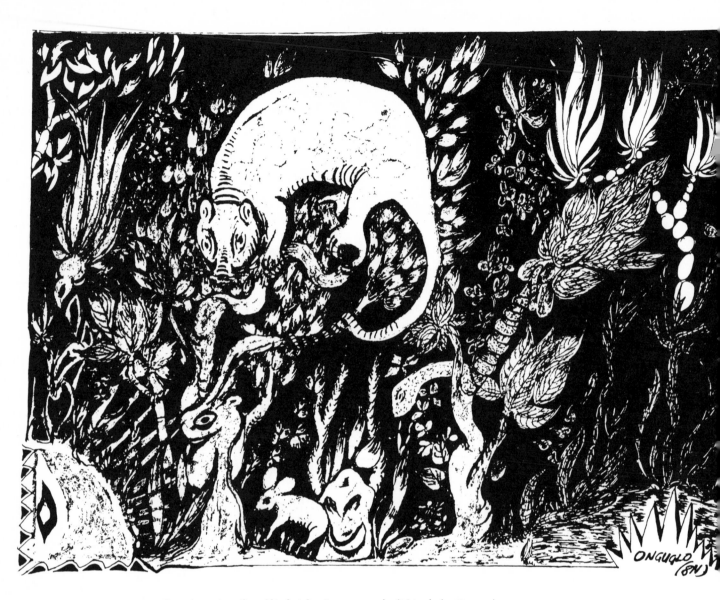

Onguglo, aged 12. One of his first drawings, very much a 'picture'. (40 × 33 cm)

Opposite: Musii Sau, aged 16. Musii took slightly more than half an hour to draw this bird. (40 × 33 cm)

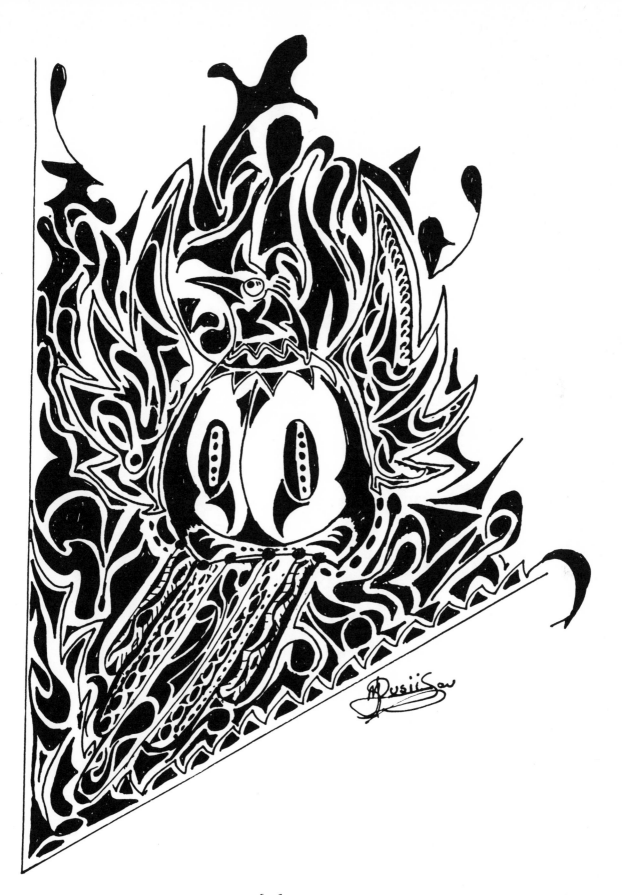

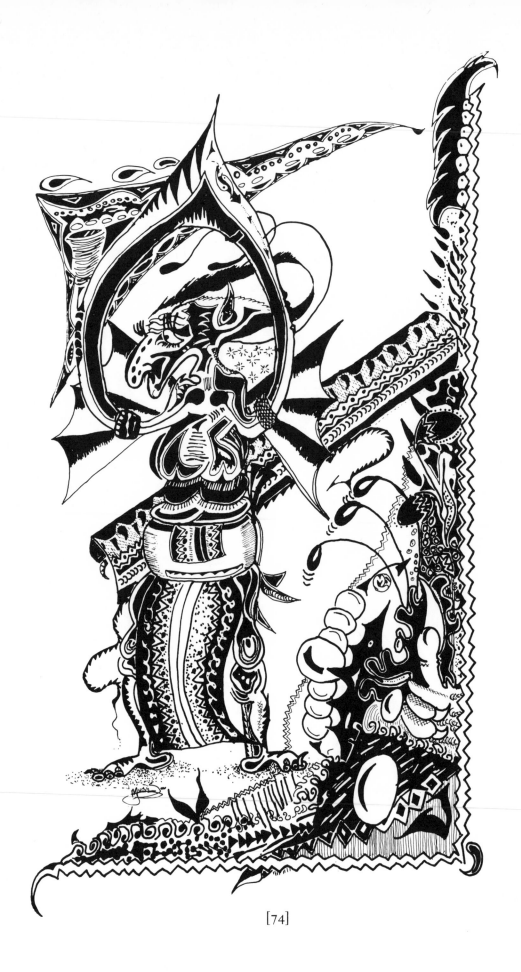

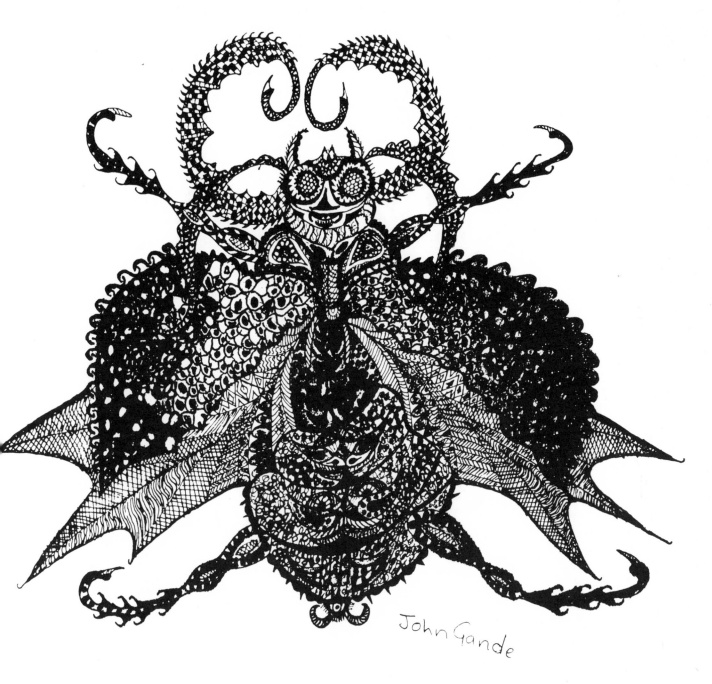

John Gande, aged 14. The range of John's work was enormous (see pages 77, 88 and 114). (55 × 40 cm)

Opposite: Musii Sau, aged 16. One of the felt-tip products of our first class and winner of a certificate of merit from the Commonwealth Institute. (50 × 30 cm)

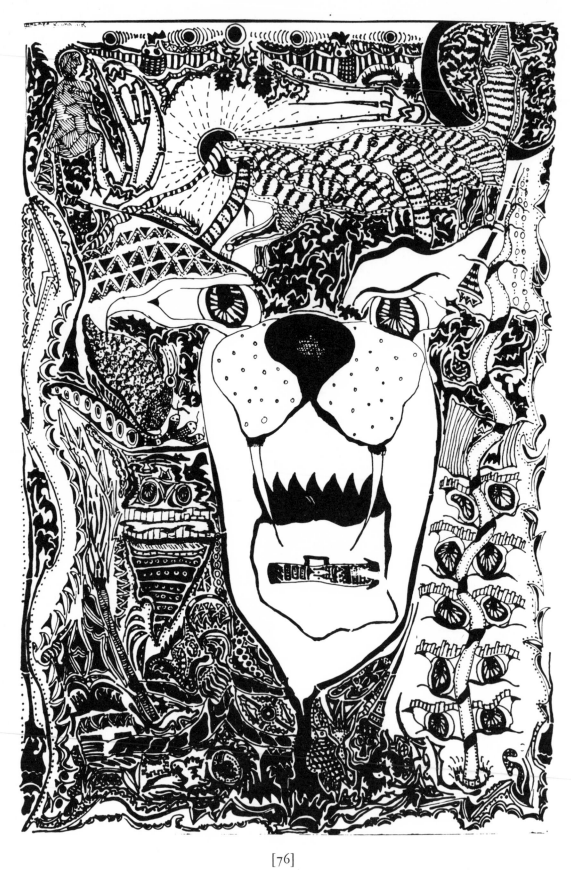

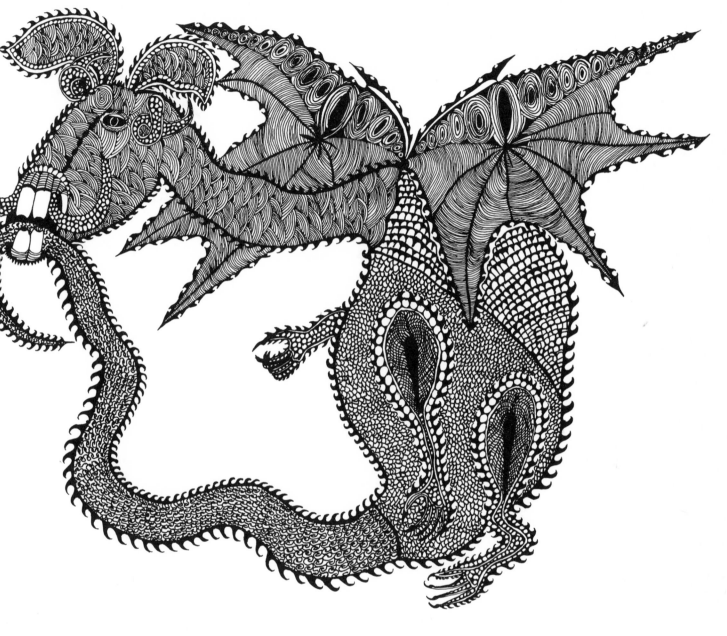

John Gande, aged 14. (60 × 45 cm)

Opposite: Taklmba Koima, aged 16. Taklmba, a very keen artist, is now at a seminary. The drum in the dog's mouth is a kundu, *commonly seen in Chimbu. (55 × 40 cm)*

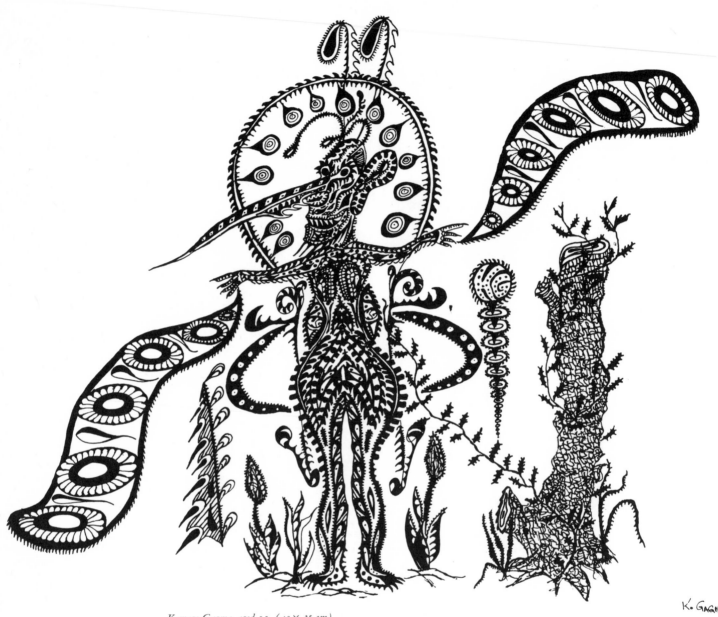

Kawage Gagma, aged 15. (40 × 35 cm)

K. GAG

Opposite: Kawage Gagma, aged 15. (40 × 30 cm)

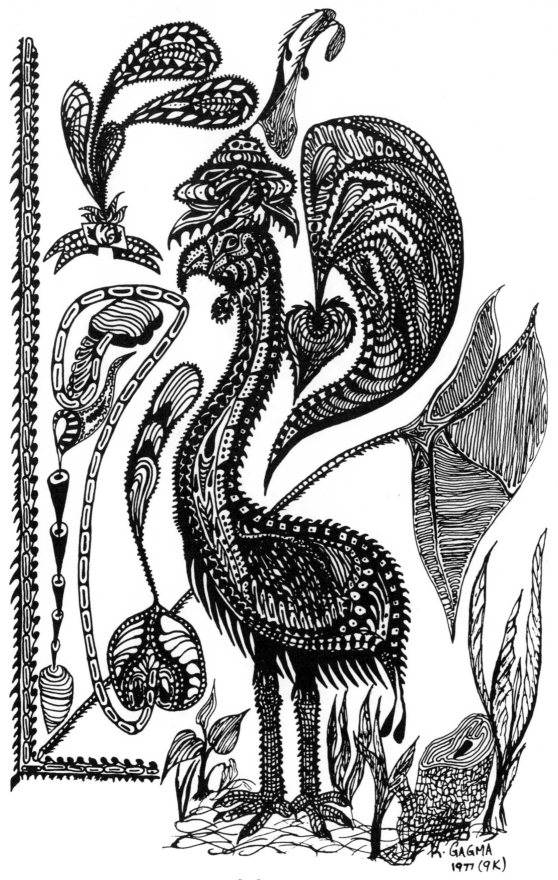

K. GAGMA
1977 (9K)

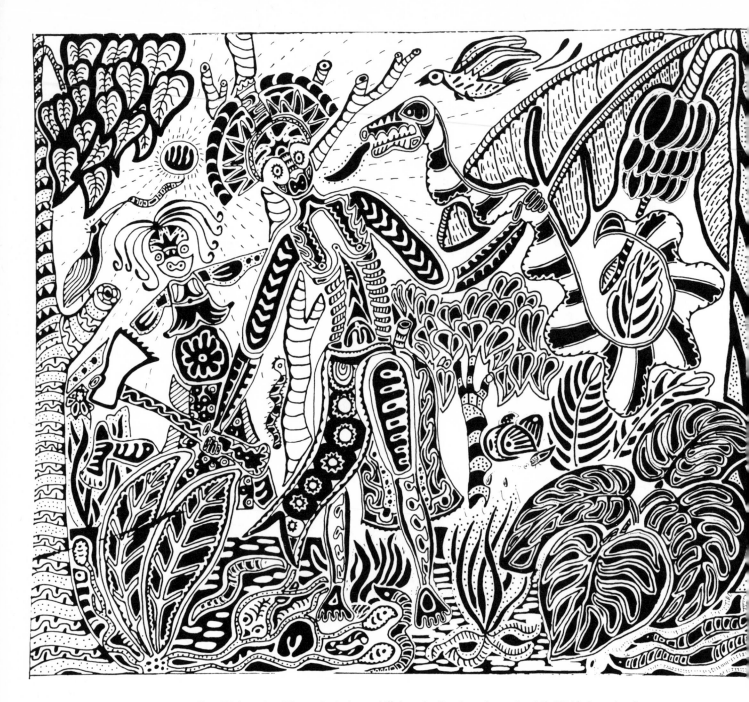

*Dara Dick, aged 16. The warrior is about to kill the snake. Dara's work was often full of highly decorative plants;
notice the bananas and the number of different kinds of leaves. She went on to Sogeri National High School.
(40 × 35 cm)*

*Opposite: Areme Gela, aged 15. One of the felt-tip drawings begun during our first art class. Notice the number of
creatures and objects decorating the head. (60 × 45 cm)*

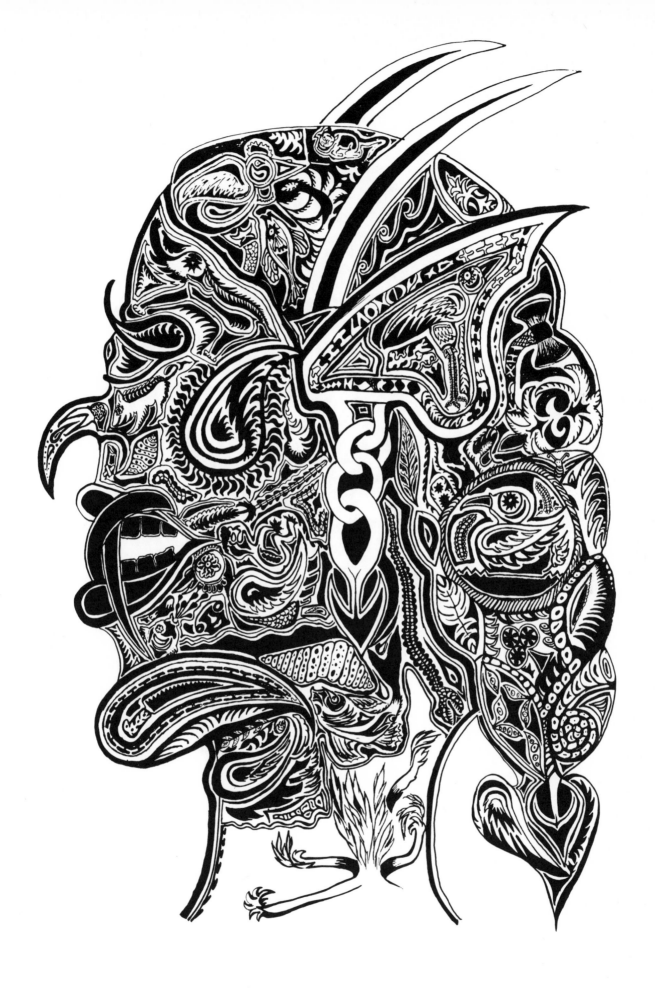

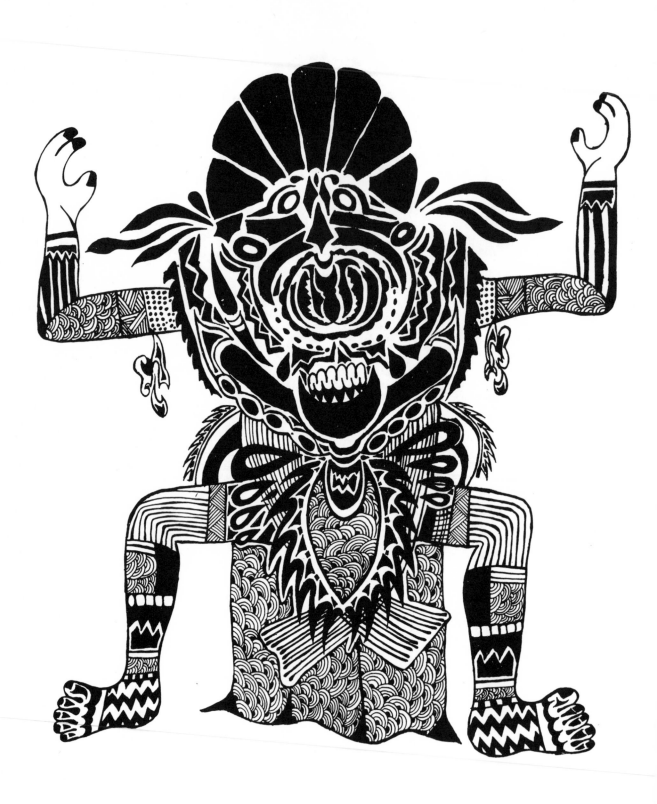

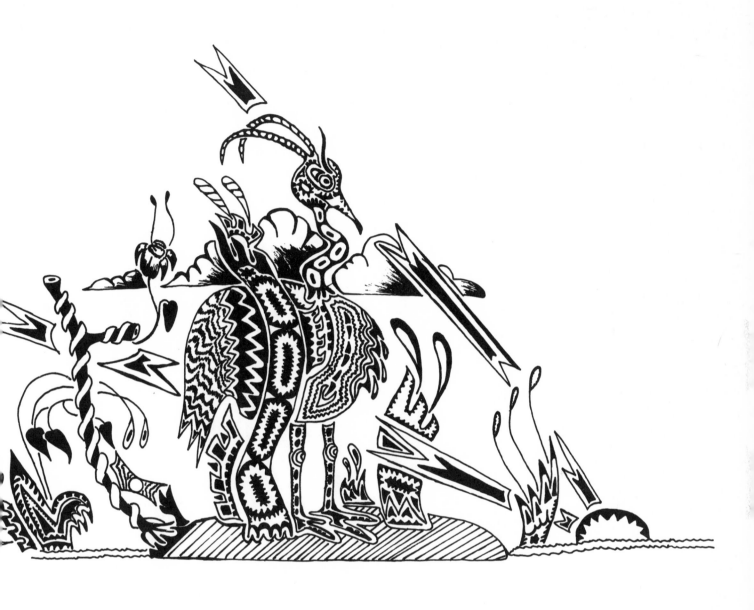

John Millan, aged 14. One of the few students whose painting was more original than his drawing. (45 × 38 cm)

Opposite: Kum Wamugl, aged 13. This type of 'stencilled' figure recurred most frequently. (40 × 35 cm)

[83]

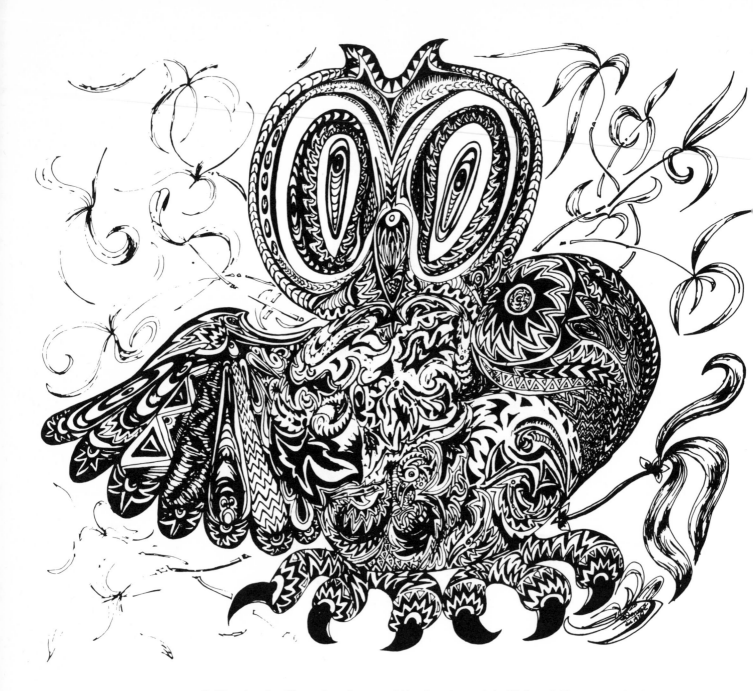

Sigl Dorugl, aged 16. The very decorative nature of this owl was characteristic of Sigl's work. He went on to university to study science. (55 × 45 cm)

Opposite: Onguglo Golka, aged 12. 'By Ignas', 'Believe', and the crucifix are probably Christian-inspired, though the drawing is rather demonic. (45 × 38 cm)

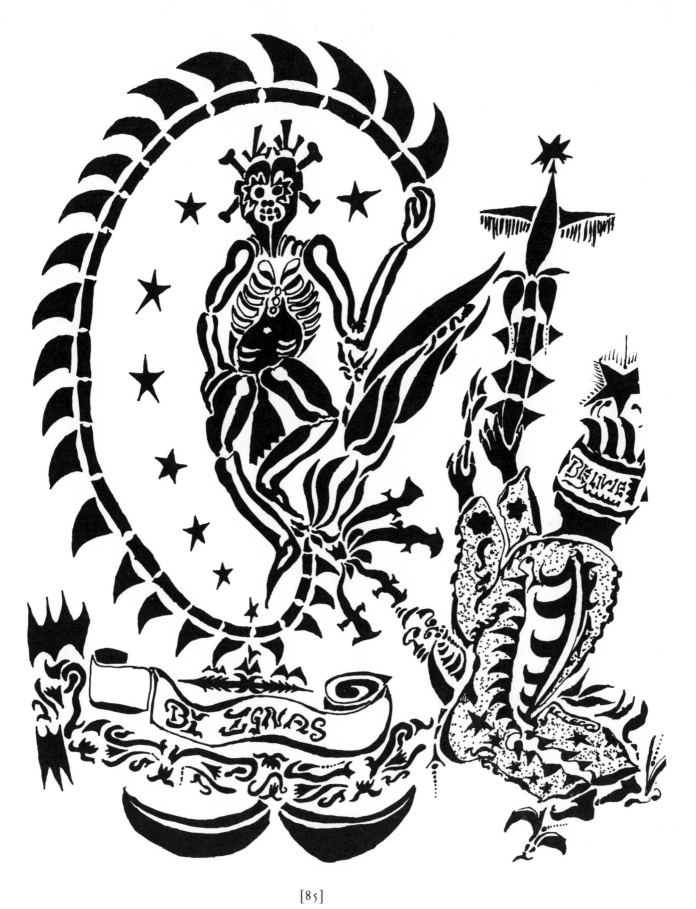

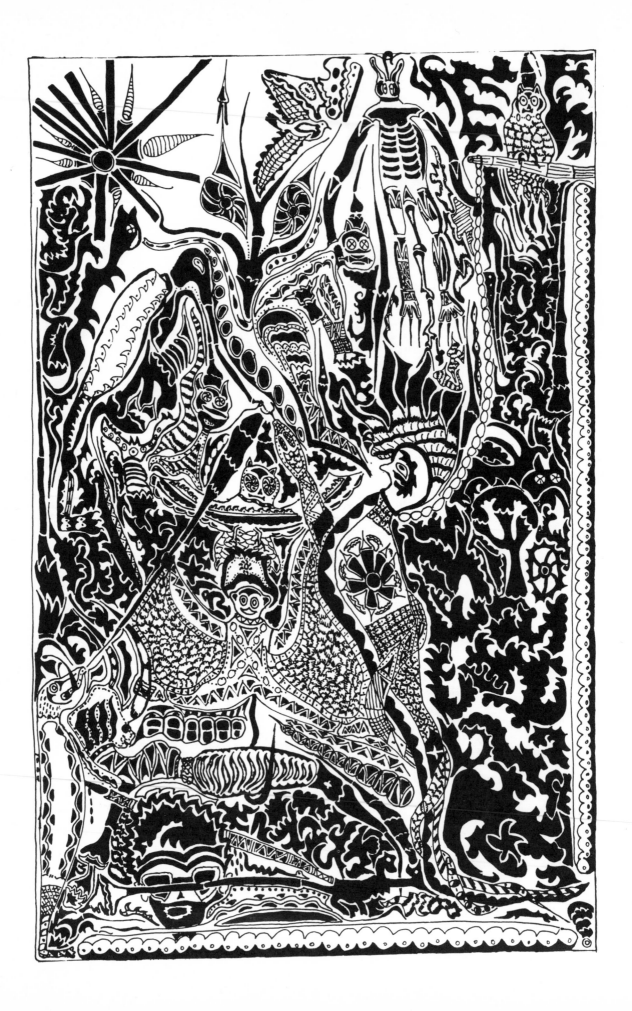

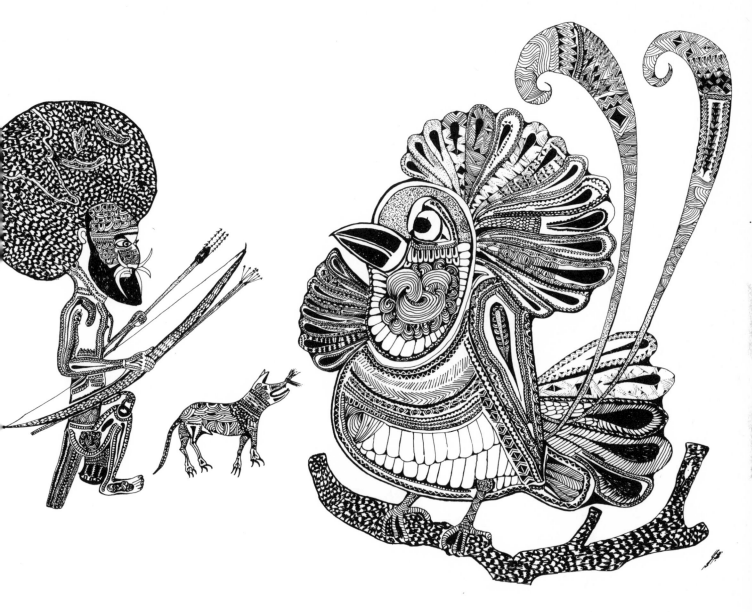

John Tei, aged 14. Bird, and hunter with dog. (80 × 60 cm)

Opposite: Taklmba Koima, aged 16. (55 × 40 cm)

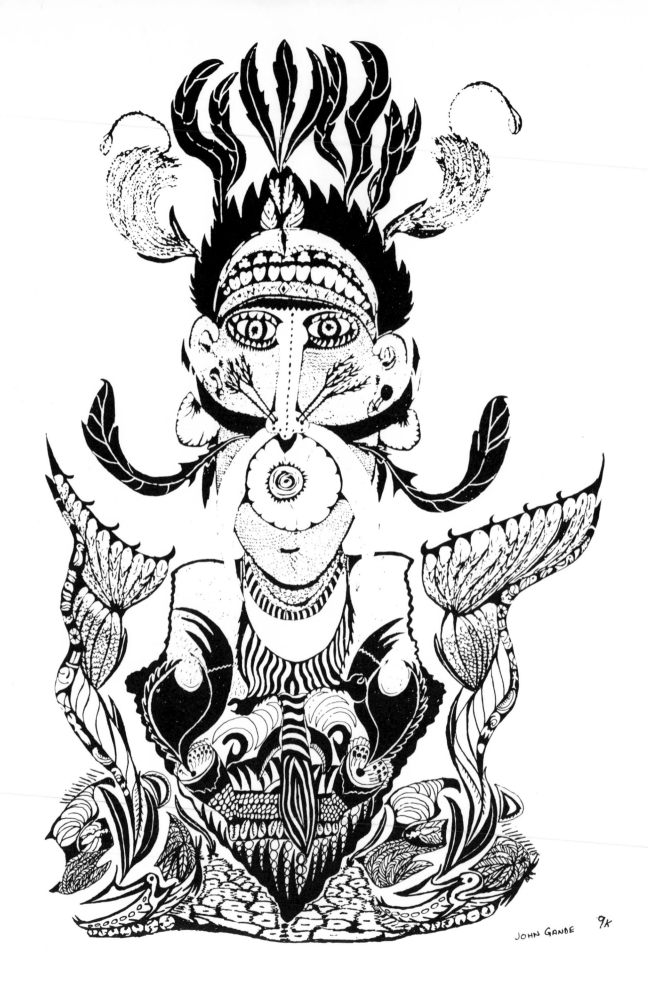

JOHN GANDE 9K

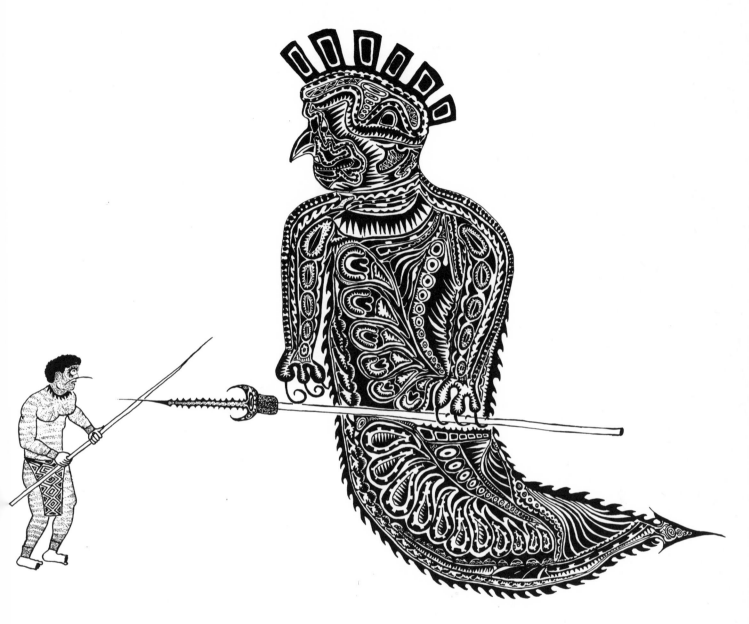

Kalpe, aged 14. (60 × 45 cm)

Opposite: John Gande, aged 15. Chimbu warrior traditionally decorated. (55 × 40 cm)

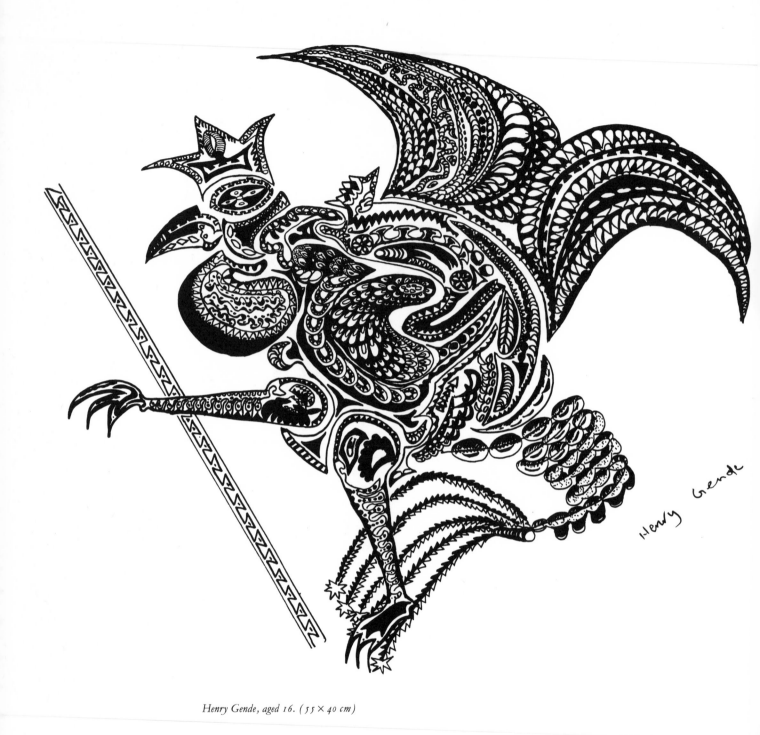

Henry Gende, aged 16. (55 × 40 cm)

Opposite: George Wasi, aged 16. George is from the Sepik Province and was a Grade 10 student at Brandi High School. (55 × 40 cm)

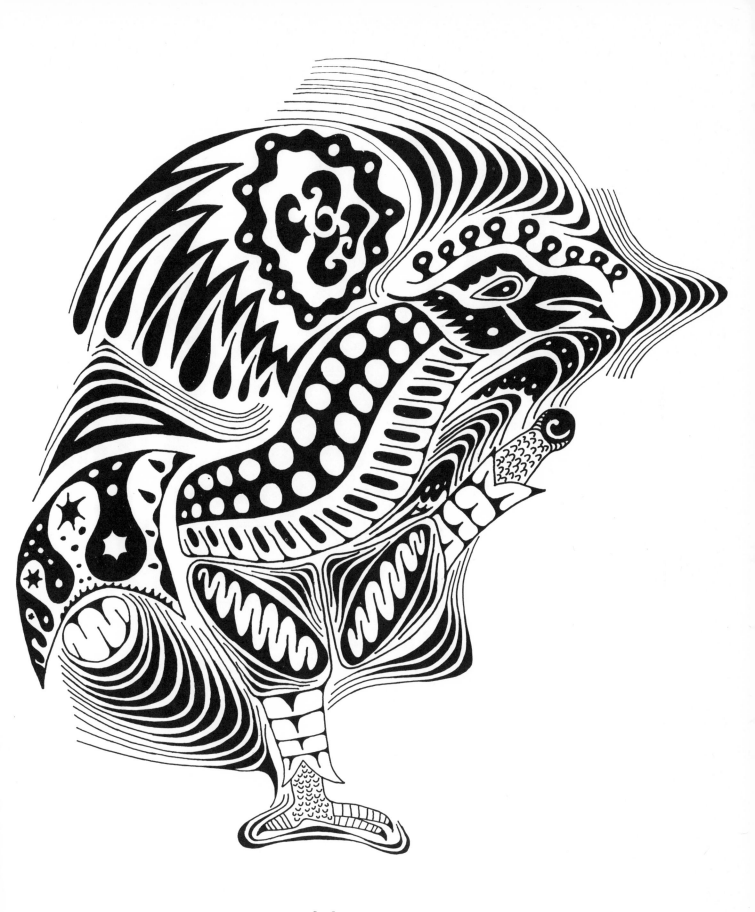

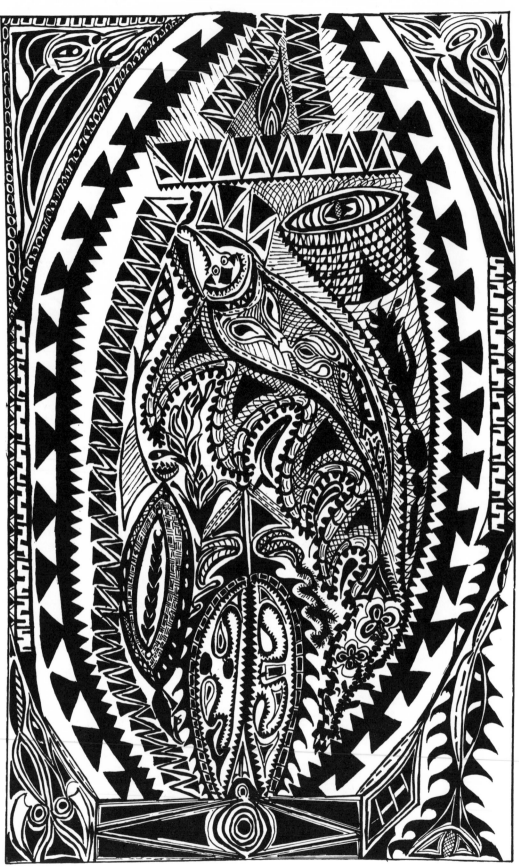

WAIANGE GEREL
10 P 1977

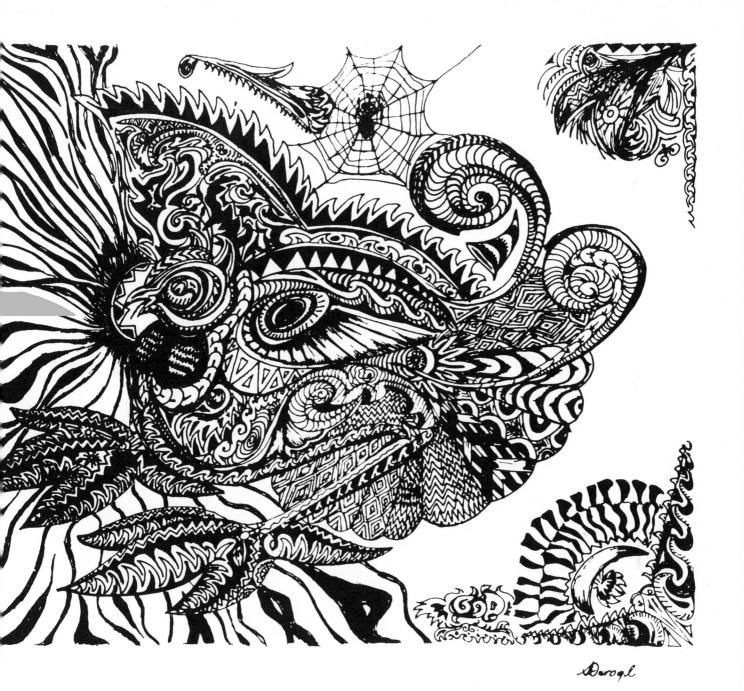

Sigl Dorugl, age 16. Sigl originally drew this to include in a portfolio for the National Arts School, but he later decided to study science. (40 × 33 cm)

Opposite : Waiange Gerel, age 15. The basic shield motif is common to coastal design work, as is the facial motif in the bottom left. (55 × 40 cm)

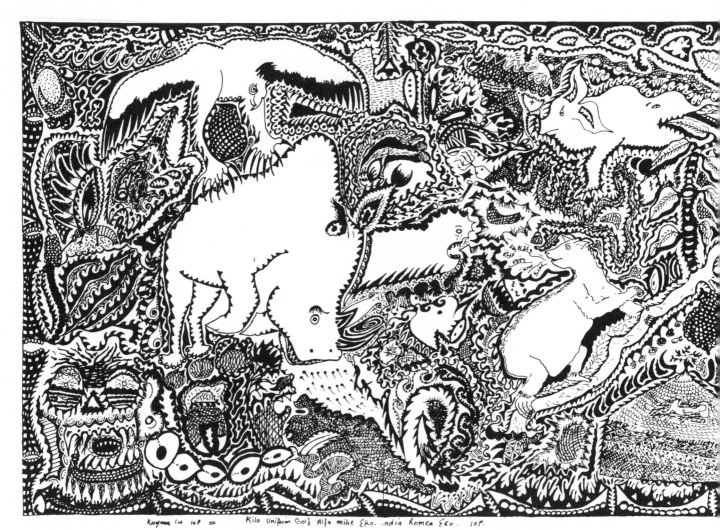

Kuglame Ire *1e* 10P = Kilo Uniform Golf Alfa mike Eko. india Romea Eco. 10P.

Kuglame Ire, aged 15, this was a result of an 'experiment'. After looking at pictures of African animals, Kuglame came away and drew the rhinoceros from memory, and embellished it. The bear is whistling 'KHS, KHS'—Kerowagi High School. (55 × 40 cm)

Opposite: Teine Gare, aged 15. More strange imagery from this artist (see page 55). (32 × 28 cm)

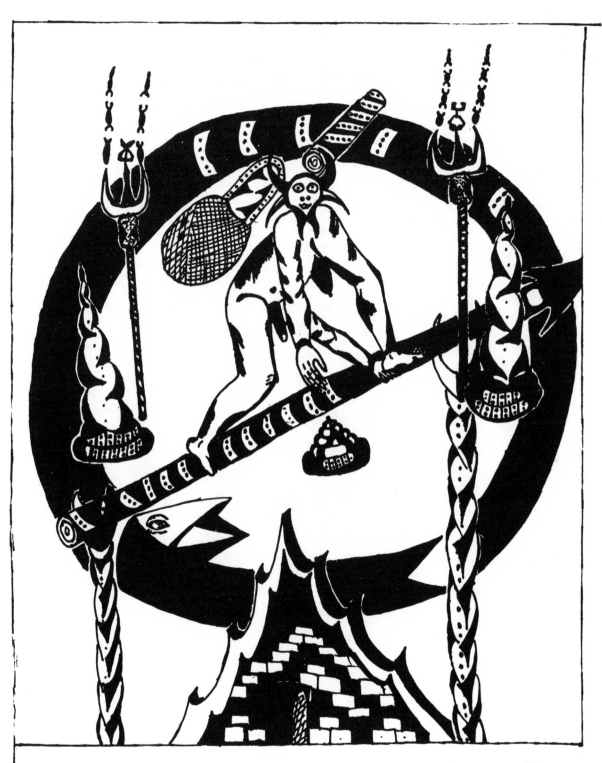

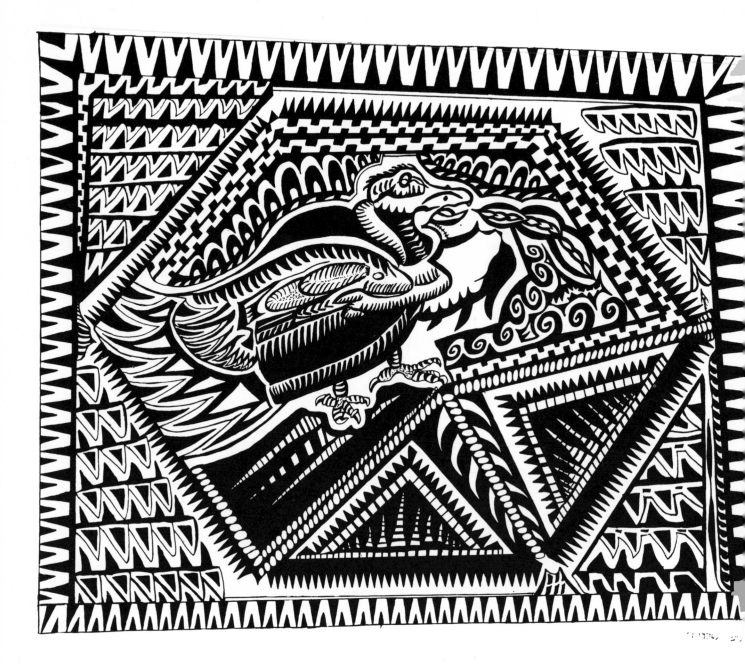

Yol Boma, aged 15, This one is very individual. A dodo in a Persian rug? (55 × 40 cm)

Opposite: John Tei, aged 15. Lady with a snake, dog, a bat and several rats. Students frequently added seemingly irrelevant things around the edges of their paper, such as the cats in this picture. (55 × 40 cm)

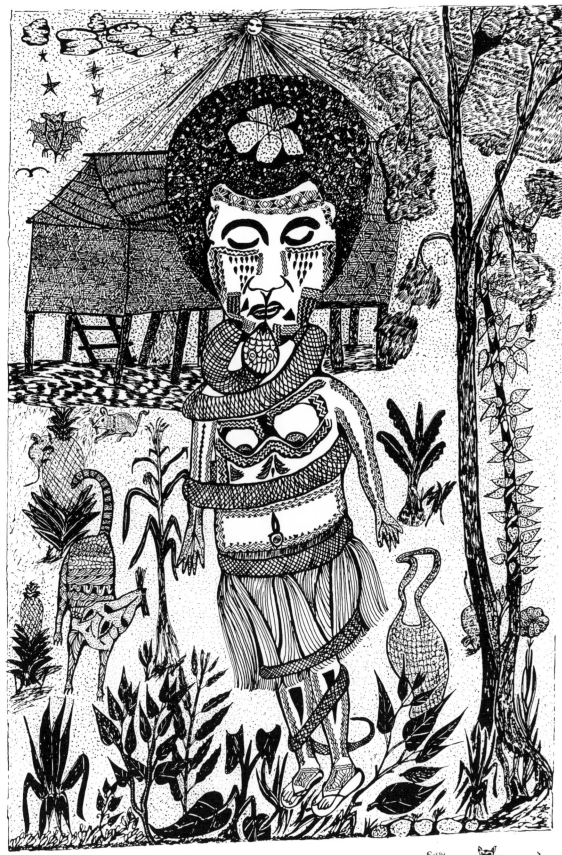

John Tei 9N

Pussy

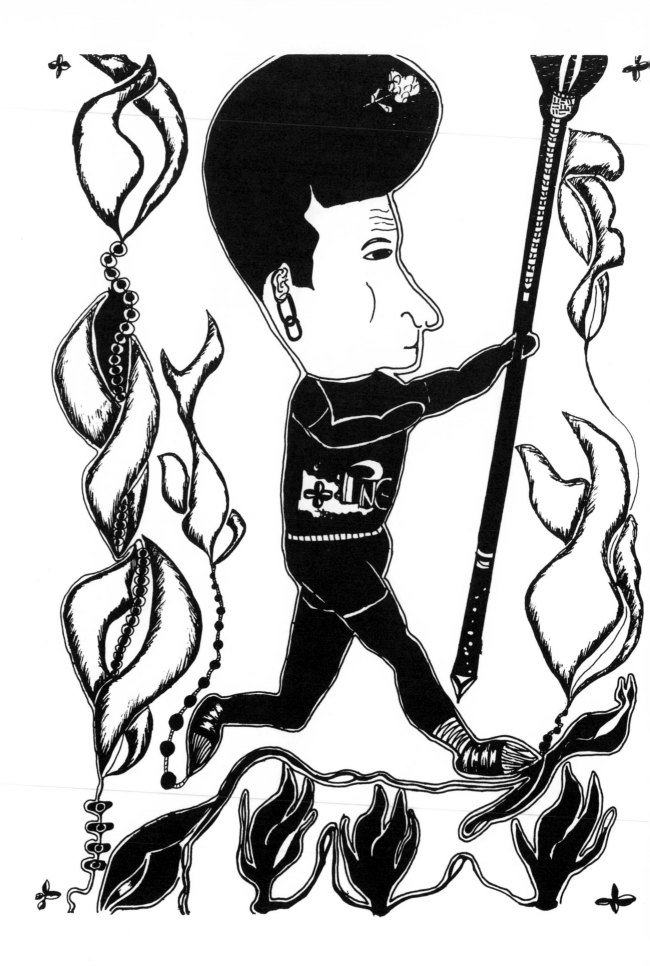

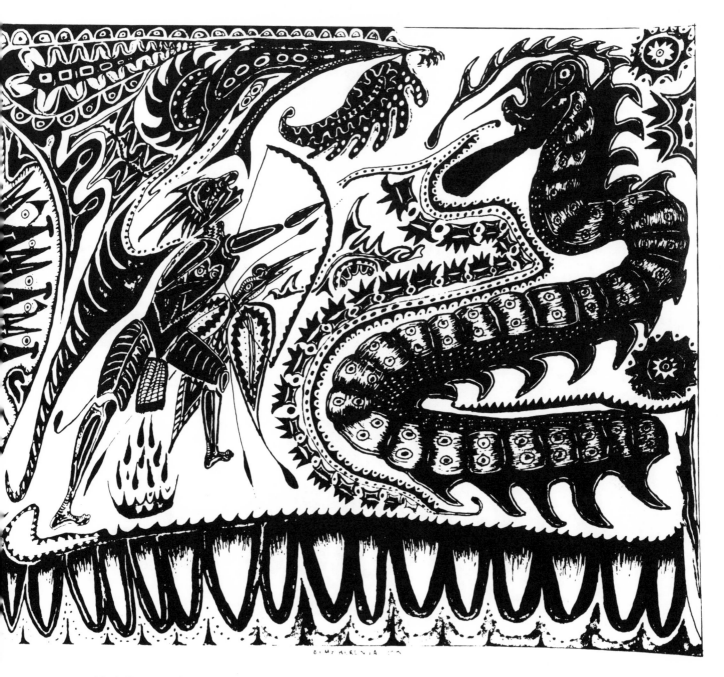

Mondo Kerenga, aged 17. Unfortunately, Mondo completed only two drawings during 1976. He went on to medical training. (40 × 35 cm)

Opposite : artist unknown. (40 × 30 cm)

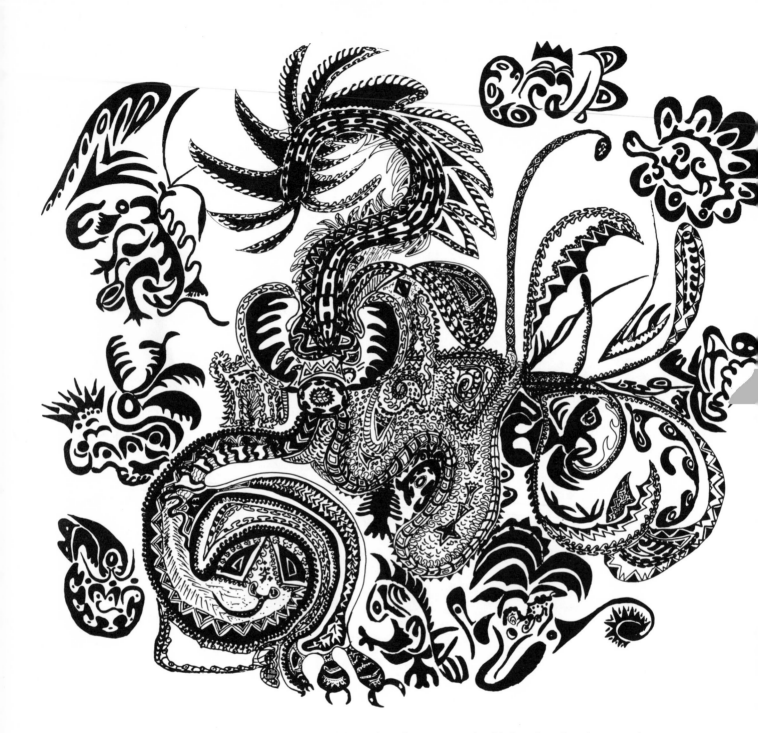

Endi Kiak, aged 15. Endi said he began this with a question mark and built up from there. (60 × 45 cm)

Opposite: Kum Wamugl, aged 13. (45 × 38 cm)

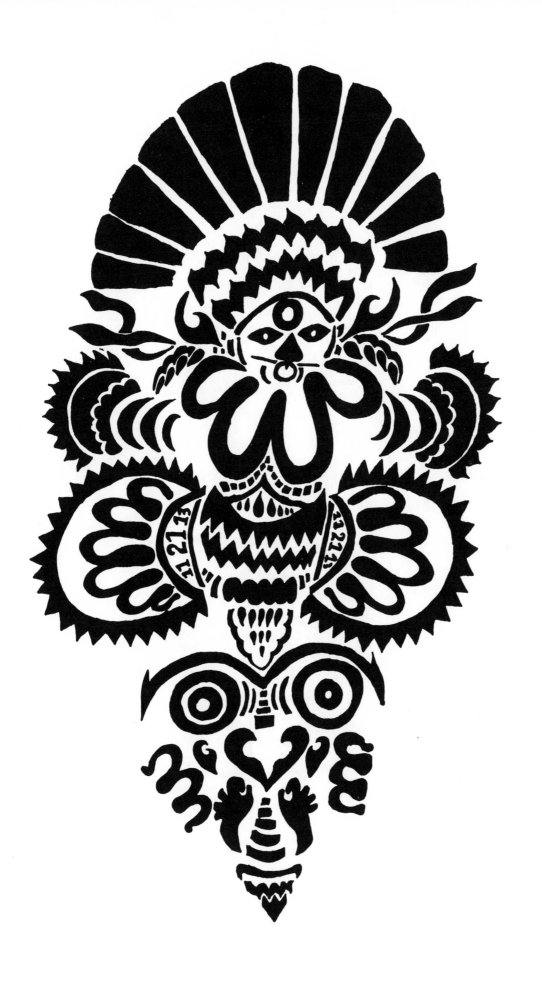

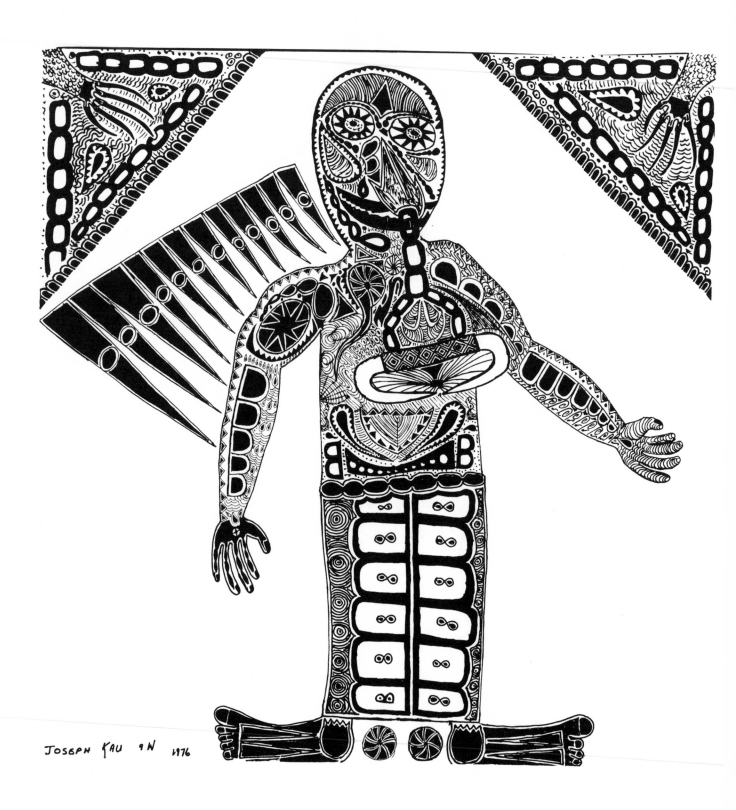

JOSEPH KAU QW 1976

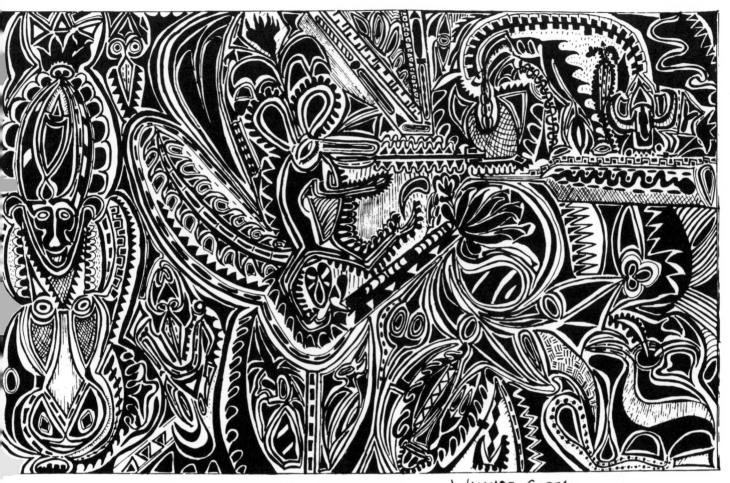

WAIANGE GEREL
10 p 1977

Waiange Gerel, aged 16. The facial motifs, particularly noticeable on the left, are a coastal feature. (55 × 40 cm)

Opposite: Joseph Kau, aged 15. (40 × 40 cm)

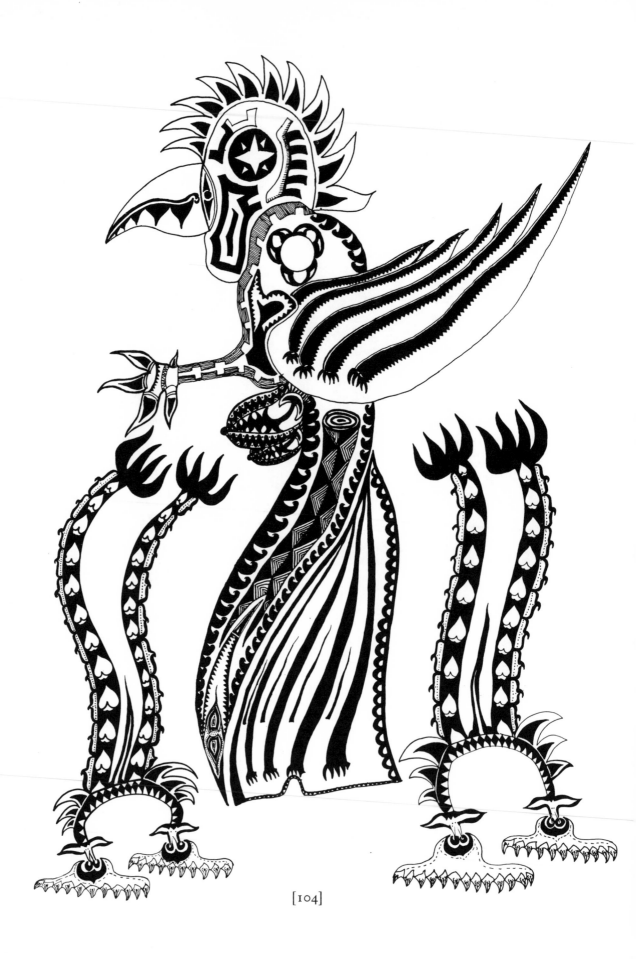

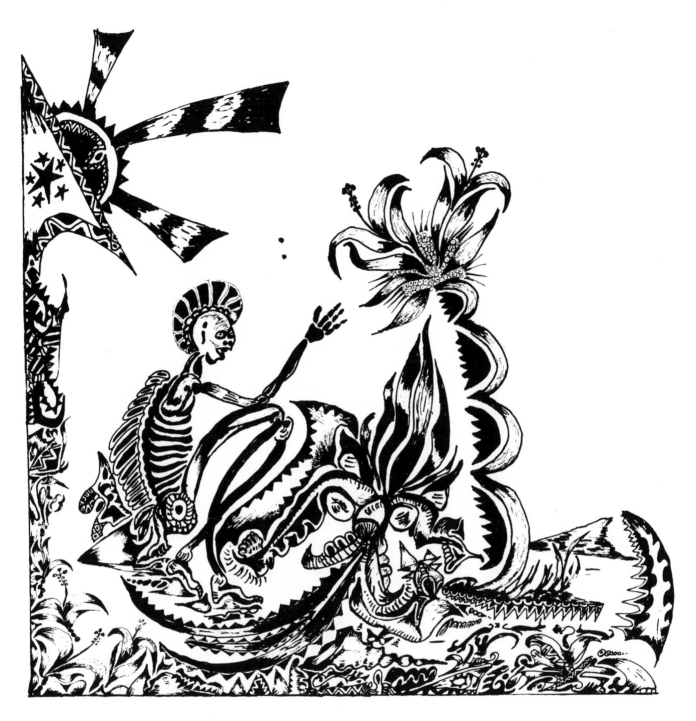

Onguglo Golka, aged 13. (32 × 28 cm)

ONGUGLO
GOKLA 8N

Opposite: Anton Kaile, aged 15. One of the felt-tip products of our first class and winner of a certificate of merit from the Commonwealth Institute. (60 × 45 cm)

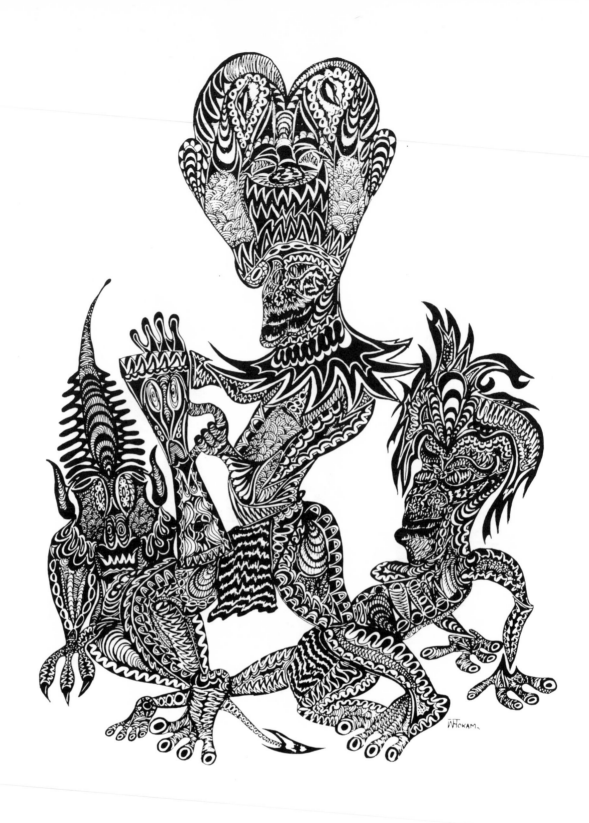

Waim Tokam, aged 16. (60 × 45 cm)

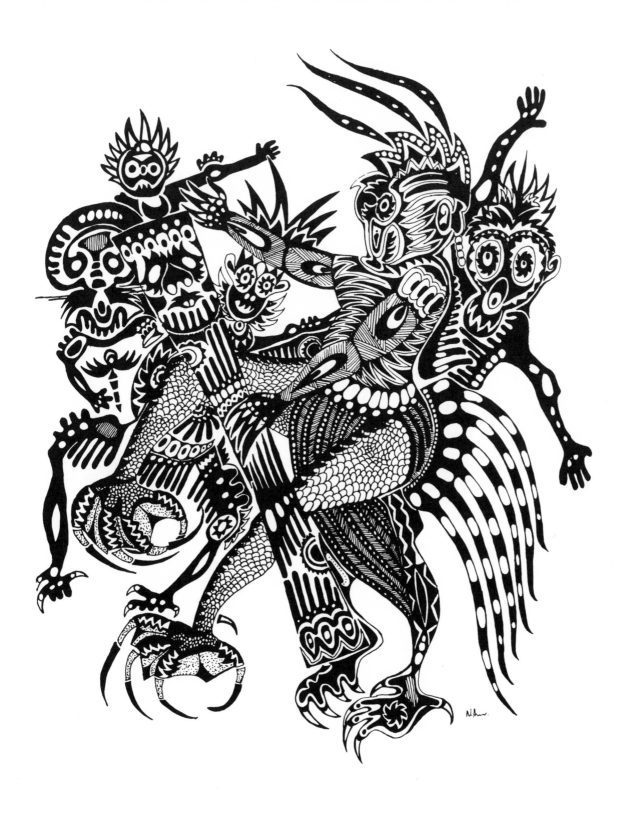

Nilak Aur, aged 16. (55 × 40 cm)

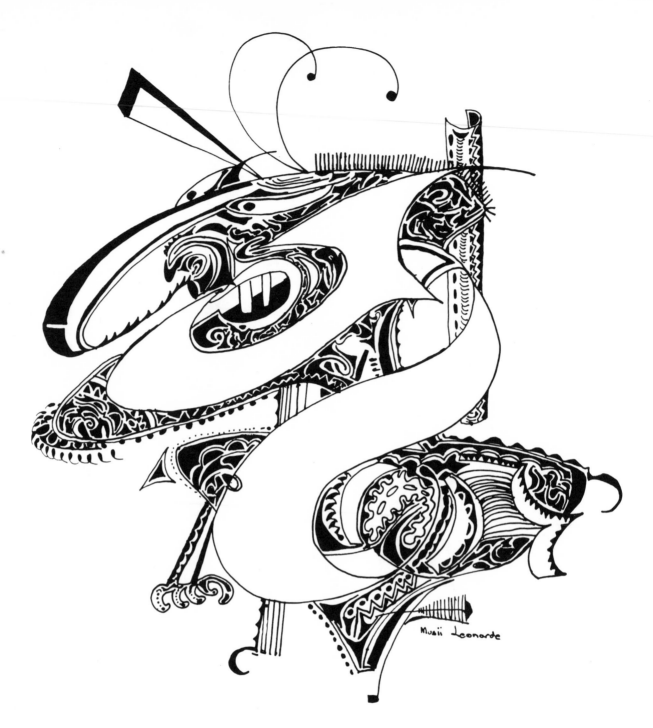

Musii Sau, aged 16. (40 × 35 cm)

Opposite : Gende Dekene, aged 13. There are a number of creatures, human and animal, in this, which, along with the small facial motifs, makes the large bird difficult to distinguish at first. (55 × 40 cm)

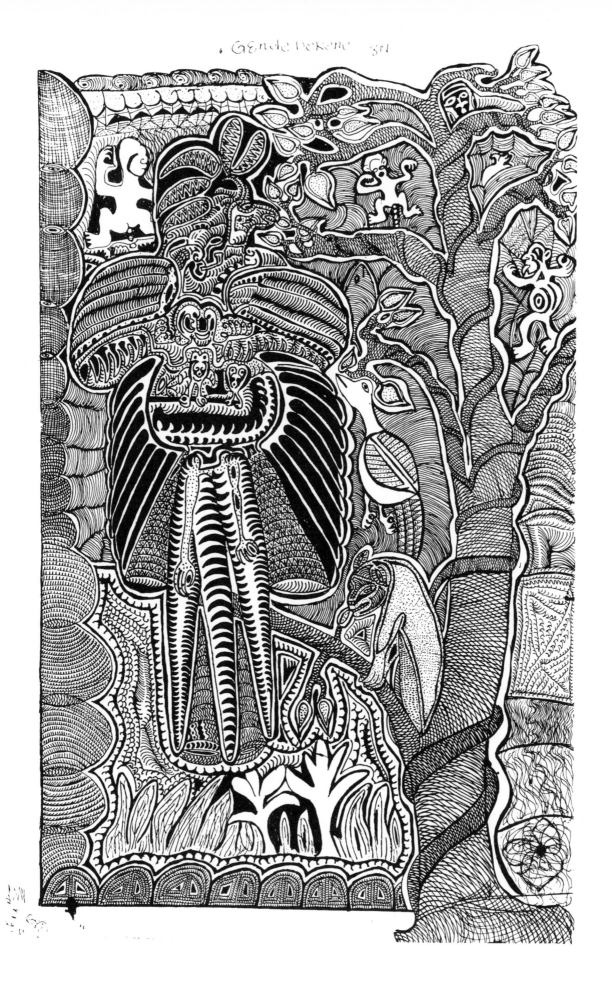

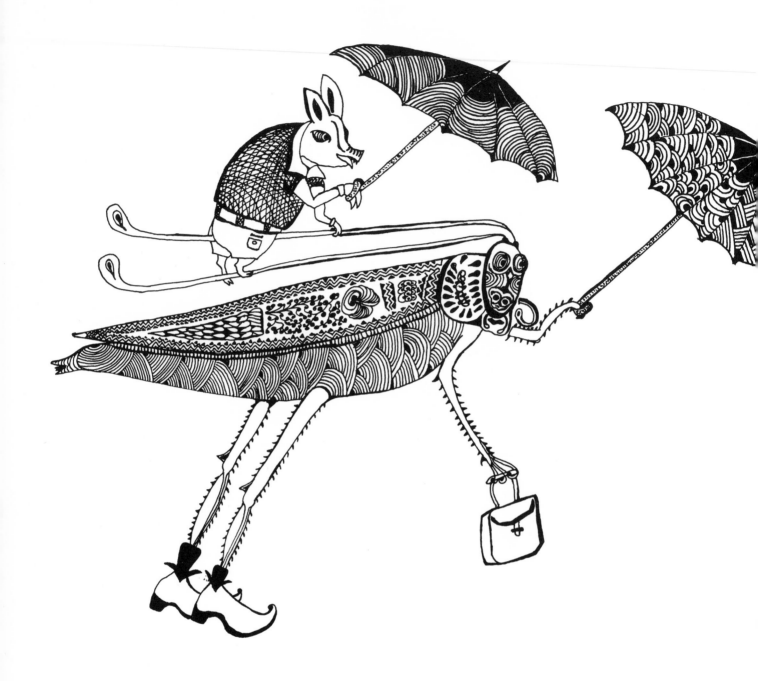

John Tei, aged 15. Western influence is particularly strong in the accessories! (40 × 30 cm)

Opposite: Yandu Yaya, aged 16. This headdress could have been influenced by the Arabian Nights. *(45 × 38 cm)*

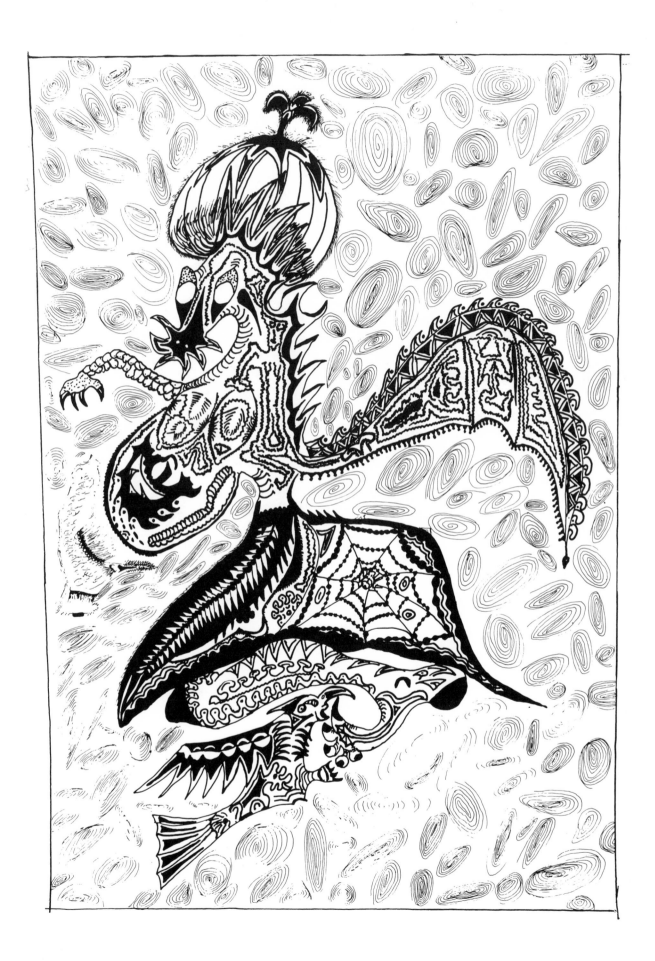

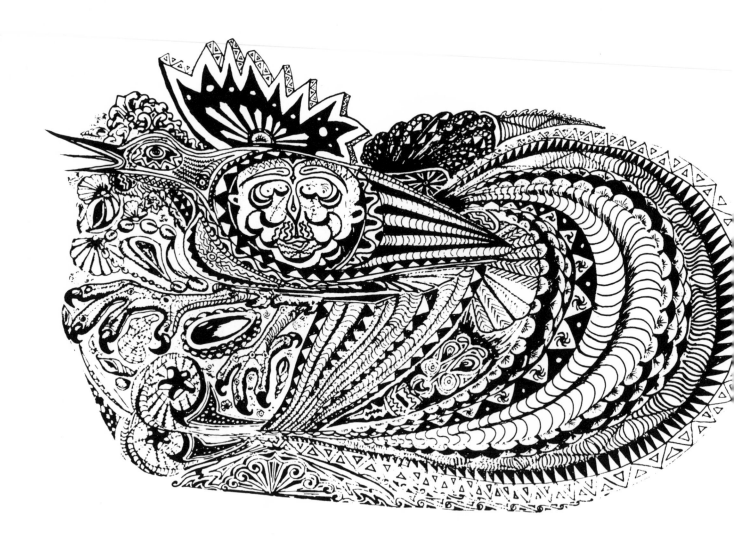

Sigl Dorugl, aged 16. One of the felt-tip products of our first art class and winner of a certificate of merit from the Commonwealth Institute. (45 × 38 cm)

Opposite: Kuglame Gabe, aged 14. (45 × 38 cm)

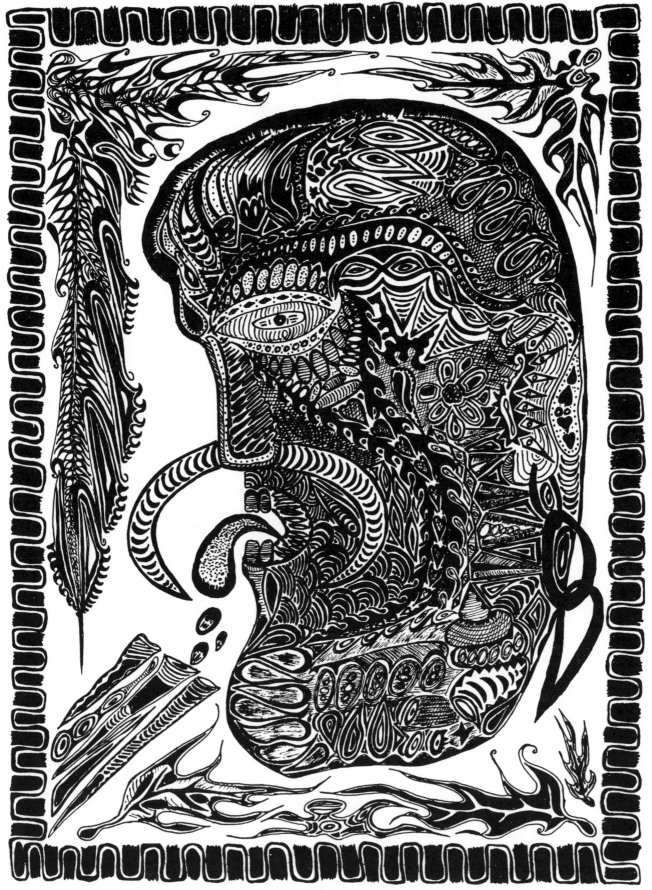

KUGLME G.
KHS

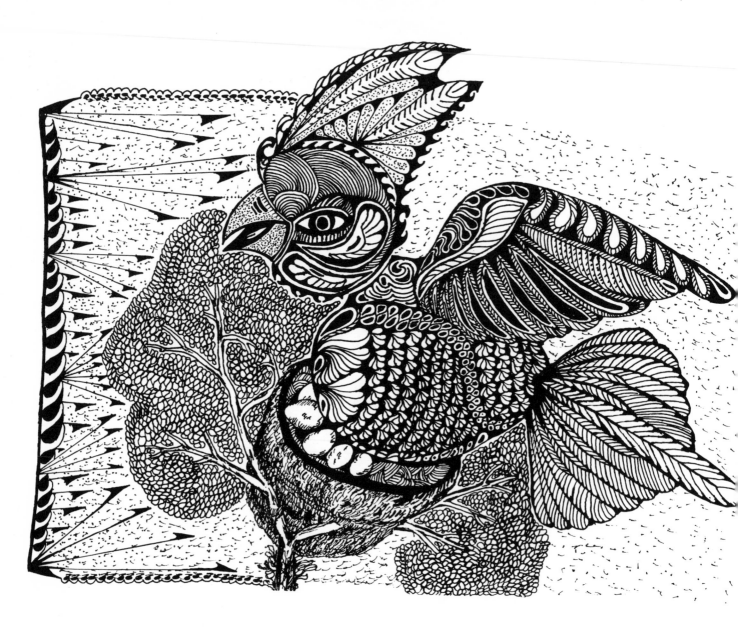

John Gande, aged 15. (55 × 40 cm)

Opposite: Gapi Kum, aged 12. (55 × 40 cm)

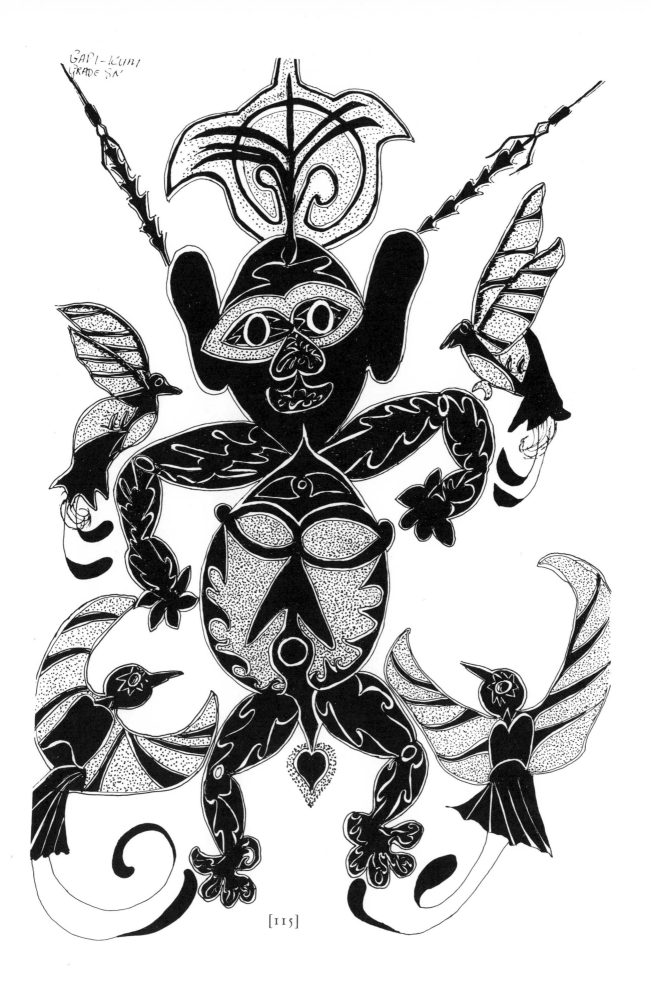

GAPI-KUNI
GRADE 5A

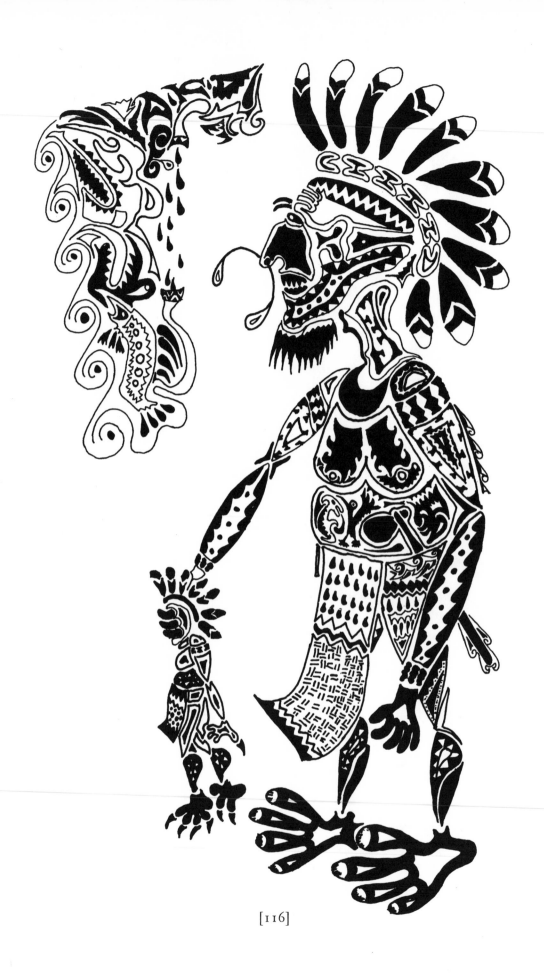

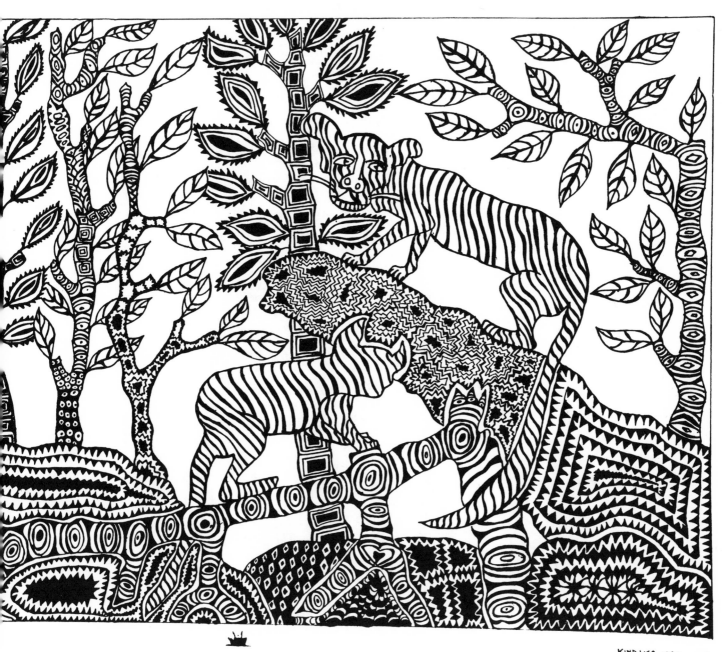

KINDIKA WAU 1015

Kindika Wau, aged 15. Unfortunately, Kindika chose to do very few drawings. (45 × 38 cm)

Opposite: Dua Dick, aged 13. Dua later made a screen-print from this design. (40 × 30 cm)

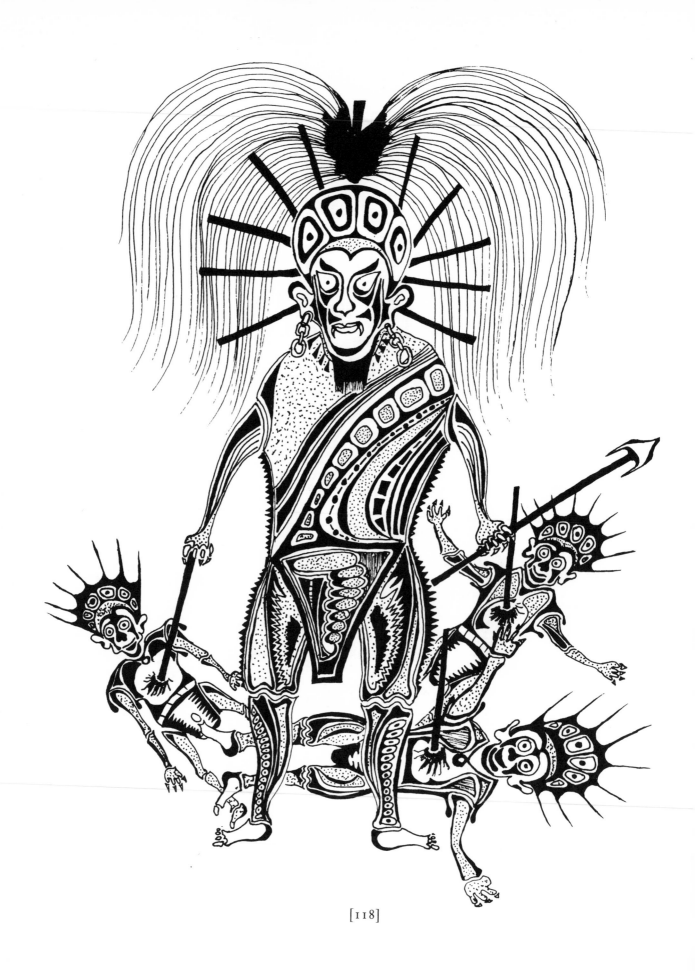

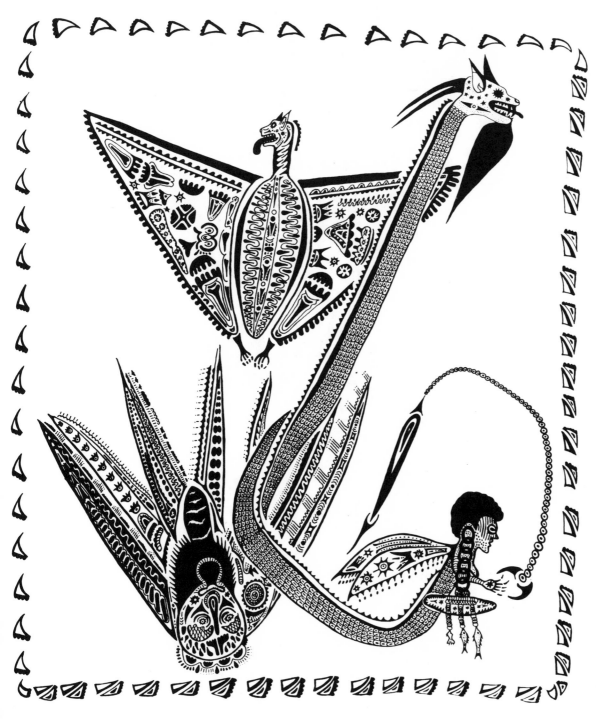

Edward Pais, aged 13. Edward is from the Sepik Province and was a Grade 8 student at Brandi High School when he drew this.

Opposite: Kalpe, aged 14. (55 × 40 cm)

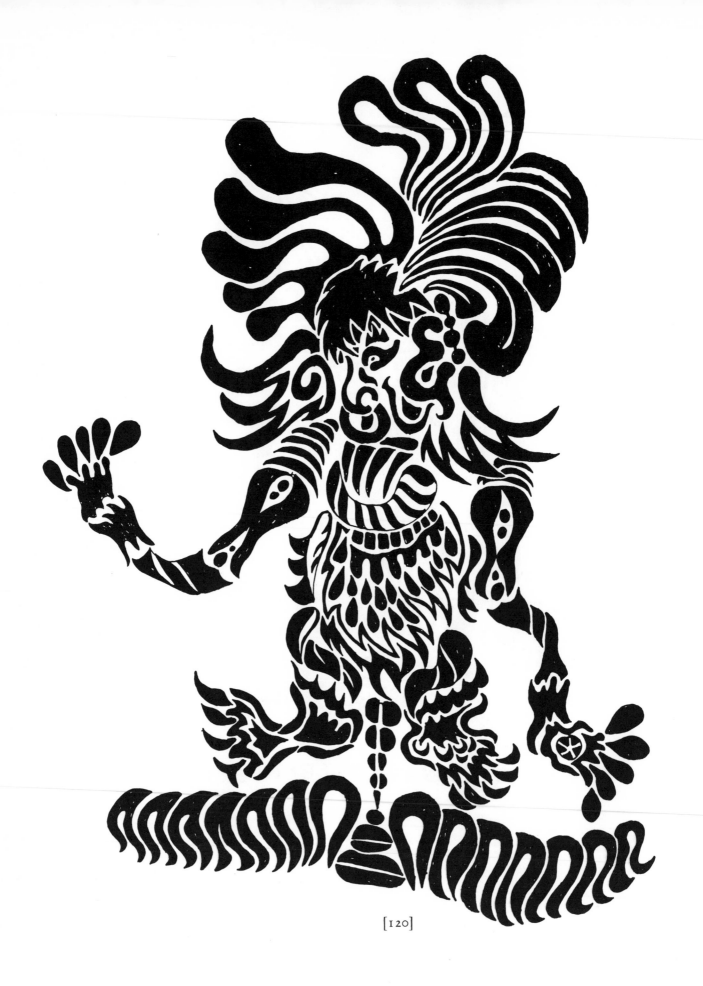

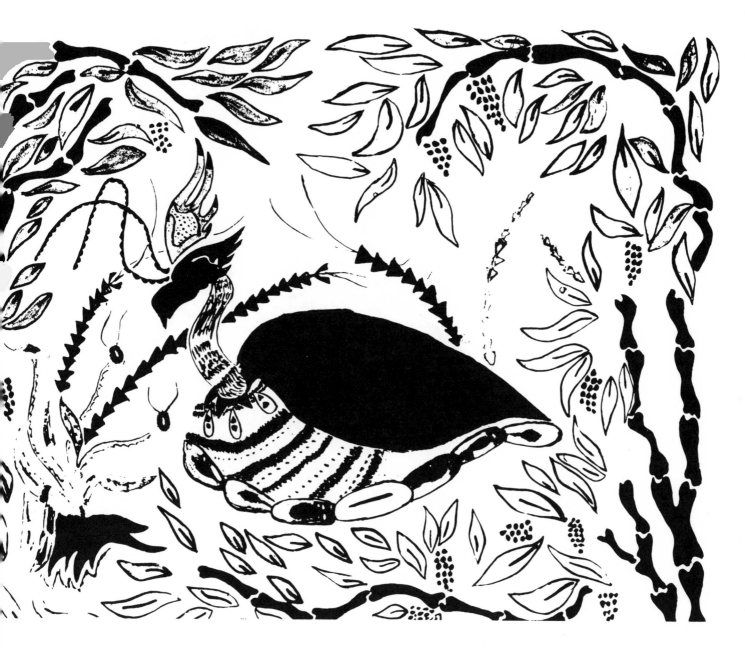

Nilak Aur, aged 15. Water colour.

Opposite: Kagl Nombri, aged 13. Kagl later made a successful screen-print (for a wall-hanging) of this design. (40 × 35 cm)

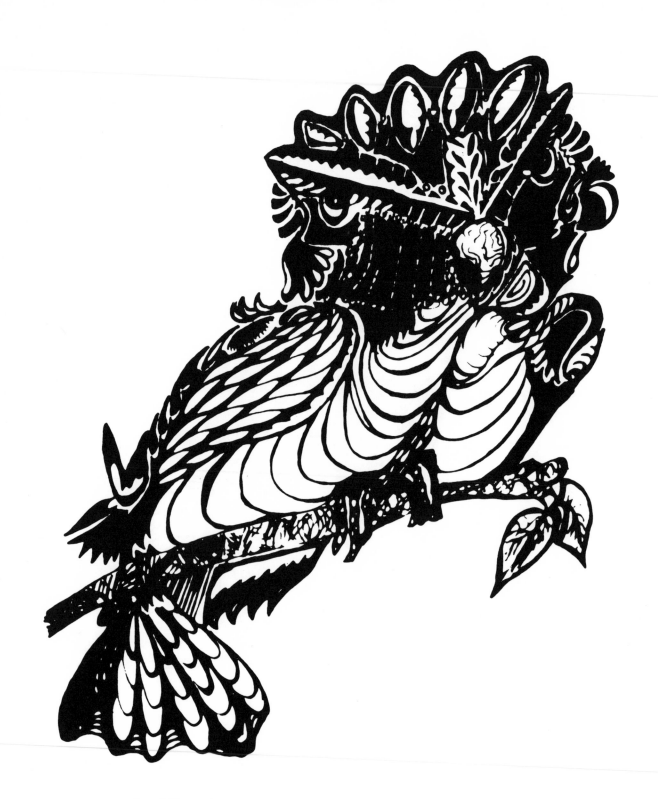

Korugl Nime, aged 13.

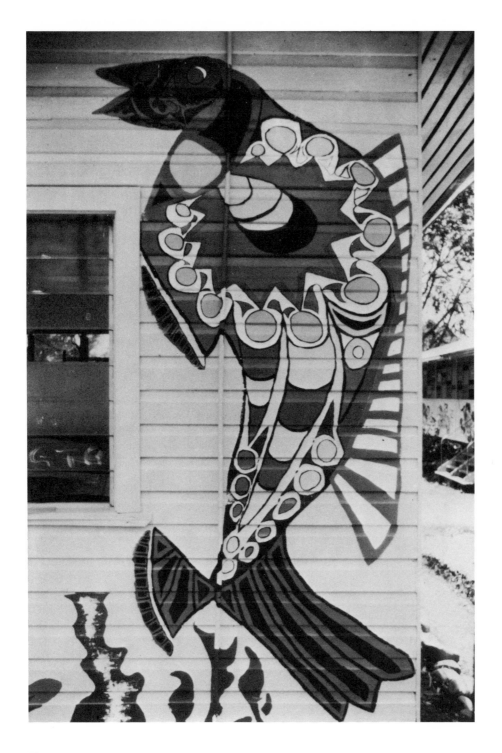

Henry Gioven, aged 13. Wall painting.

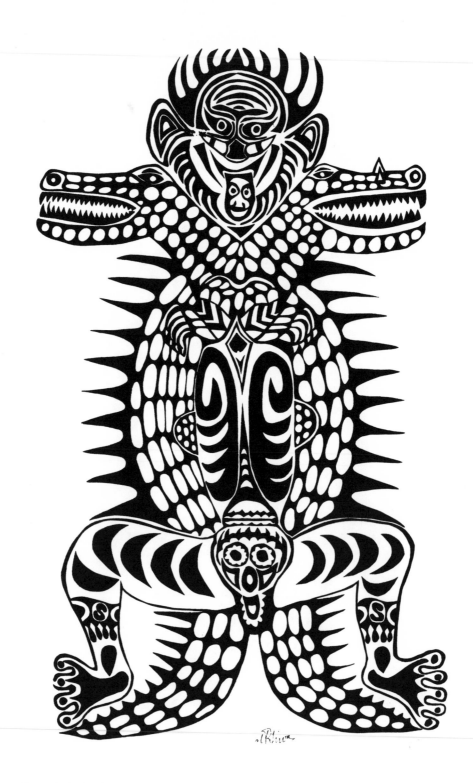

Drawn by Joachim Miway, aged 18, a Sepik student at Sogeri National High School. Traditional coastal influence.

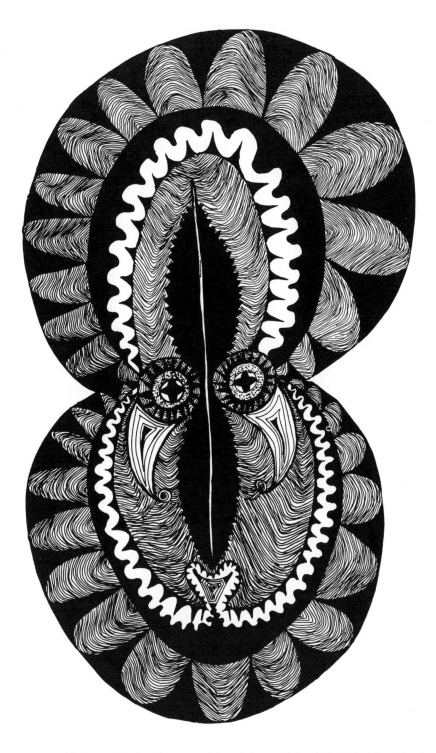

Drawn by Anton Mudugam of Madang Province, a student at Aiyura National High School. Traditional coastal influence.

Bibliography

Arts of the South Seas, Ralph Linton and Paul Wingert, pub. Museum of Modern Art, New York (1946)

The Chimbu, Paula Brown, pub. Schenkman Publishing Company Inc. (1972)

Papua/New Guinea, Peter Hastings, pub. Angus and Robertson (1971)

Plumes and Arrows, Colin Simpson, pub. Angus and Robertson (1962)

Assignment New Guinea, Keith Willey, pub. Jacaranda Press Pty, Ltd. (1965)

Outsider Art, Roger Cardinal, pub. Studio Vista (1972)

Photographic Acknowledgements

The photographs on the following pages were taken by Frank Binkley: 3, 4, 11, 12, 16, 23, 24, 47, and 48. Other photographs are by the author.